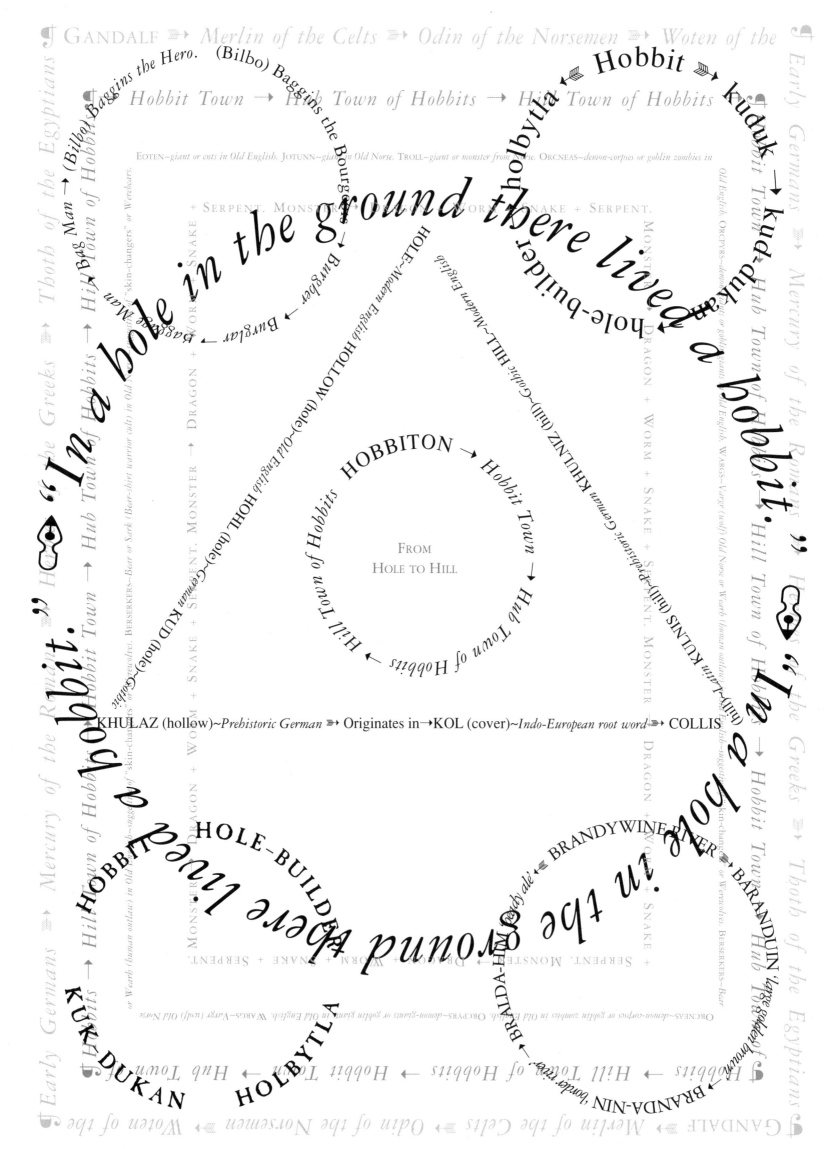

FROM
HOLE TO HILL

"In a hole in the ground there lived a hobbit."

KHULAZ (hollow)~*Prehistoric German* ⇒ Originates in →KOL (cover)~*Indo-European root word* ⇒ COLLIS

HOBBITON → Hobbit Town → Hub Town of Hobbits → Hill Town of Hobbits

HOLE-BUILDER

HOLBYTLA

KUD-DUKAN

BRANDYWINE RIVER · BRANDA-NIN 'border water' · BRALDA-HÍM 'heady ale' · BÁRANDUIN 'large golden-brown'

the hobbit companion

DAVID DAY

ILLUSTRATIONS BY

LIDIA POSTMA

PAVILION

To Alan and Jean Day on their 50th Anniversary,
and Brian and Mariette Day on their 10th Anniversary

First published in Great Britain in 1997 by
PAVILION BOOKS LIMITED
64 Brewery Road
London
N7 9NT

A member of the Chrysalis Group plc

Text copyright © 1997 David Day
The moral right of the author has been asserted

Illustrations copyright © Lidia Postma

Art direction and design by David Costa & Fiona Andreanelli at Wherefore Art?

A CIP record for this book is available from the British Library

ISBN 1 85793 937 9

Printed and bound by Imago Productions, Singapore

2 4 6 8 10 9 7 5 3

The Tolkien Society

Honorary President: the late Professor J. R. R. Tolkien in perpetuo

Founded in London, England, in 1969, The Tolkien Society provides a meeting point for all those who value the works of Professor J. R. R. Tolkien. The society is an independent educational charity, run by and for Professor Tolkien's admirers. Members are kept in touch by the bi-monthly bulletin magazine *Amon Hen*. Our annual journal, *Mallorn*, contains longer papers and members' own stories, poetry and artwork.

The Society organizes three major meetings a year: Oxenmoot in Oxford in September, the AGM and Dinner in the Spring and the Seminar in the summer. Local groups or "smials" have been set up throughout the world.

Details of subscription rates in the UK and elsewhere may be obtained from The Tolkien Society (PB), Annie Haward, St. Peter's College, Oxford OX1 2DL. Questions about J. R. R. Tolkien's life and works are also welcome. Please enclose a stamped, self-addressed envelope or (from outside the UK) an international reply coupon.

Table of Contents

I. In the Beginning was *the Word:* "HOBBIT"

It came into being on a certain fateful summer afternoon in Oxfordshire in 1930. It was not exactly an invented word, but nobody had ever really used it in quite the way Professor J. R. R. Tolkien did when he scribbled it down on a scrap of paper in his study at Number Twenty Northmoor Road in suburban Oxford.

The word *Hobbit* was soon to be as much a magical word for Professor Tolkien as *Hocus-Pocus* was for any fairy-tale magician. In fact, Hobbit was the most important single word that ever inspired him to invent a story.

Most authors create characters and then find names for them, but Professor Tolkien's mind reversed that order. He always acknowledged that it was words themselves that suggested characters, creatures, races, species, plots, places, and entire worlds to him.

Above all things, J. R. R. Tolkien was a scholar who studied words—a philologist—and he was one of the compilers of the prestigious *Oxford English Dictionary*. Consequently, in his creative fiction, words themselves proved to be his chief source of inspiration.

This was absolutely true of his new word: Hobbit.

What do we really know about the arrival of Tolkien's Hobbit? Superficially, not much. Tolkien himself tells us about the moment of the word's delivery. He makes it sound like an unannounced and anonymous letter—with no postmark and no return address—dropped into his mailbox.

"All I remember about the start of *The Hobbit* is sitting correcting School Certificate papers in the everlasting weariness of that annual task forced on impecunious academics with children. On a blank leaf I scrawled: 'In a hole in the ground there lived a hobbit.' I did not and do not know why."

The human imagination is a complex and peculiar thing: part magpie and part magician. It is common for authors and artists blessed with creative powers to refuse to tamper with the imagination. However, Tolkien was also a trained scholar, and he actually knew a lot about the forces that shaped the Hobbit and his world. Many years after *The Hobbit* had been published Tolkien wrote expansively about this seminal moment.

"One of the candidates had mercifully left one of the pages with no writing on it (which is the best thing that can possibly happen to an examiner) and I wrote on it: 'In a hole in the ground there lived a hobbit.' Names always generate a story in my mind. Eventually I thought I'd better find out what hobbits were like. But that's only the beginning."

So, Tolkien himself said it: in the beginning was the word—Hobbit. Furthermore, in his writing, "I thought I'd better find out what hobbits were like," we can clearly see Tolkien's creative mental process at work. Many authors talk about creating a character, but whenever someone asked Tolkien about a character (or a race or a thing or a place) that was named but not yet fleshed out in the text of his stories, he would invariably say, "I'll go and try to find out more about it."

That is, Tolkien behaved as if that character (or thing or place) existed in a sort of parallel world where its whole nature was waiting to be discovered and recorded in the most minute detail. Tolkien did not see his job as a writer as being that of a creator but that of an explorer and chronicler of an already existing world that awaited discovery through the language itself.

This book is an exploration of the inspirational power of language. It proposes that the entire body of Tolkien's writing dealing with Hobbits was essentially the product of a list of associations with the word Hobbit. Thus, the invention of the word Hobbit resulted in the creation of the character, race, and world of the Hobbit.

If this appears to be a peculiar form of circular thinking, that is exactly what is intended. Tolkien invents a philological origin for the word Hobbit as a worn-down form of an original invented word *holbytla* (which is actually an Old English construct) meaning "hole-builder." Therefore, the opening line of *The Hobbit* is meant as an obscure lexicographical joke. It is a deliberate tautology: "In a hole in the ground there lived a hole-builder."

꿍*"In a hole in the ground there lived a hobbit."*
Hobbit → hole-builder

To take the circular approach a stage further, one can look at the Modern English word *hole,* which is derived from the Old English *hollow.* By bizarre coincidence, hollow originally came from the Old German *hohl*—pronounced "hole."

Not content with the spiral ending there, Tolkien couldn't resist adding a few more twists by stating that the word

hobbit as a worn-down form of holbytla was not used by the Hobbits themselves. In their own Hobbitish speech they were known as *kuduk,* a worn-down version of *kud-dukan*—meaning "hole-builder"—which were Gothic constructs that Tolkien derived from the Prehistoric German word *khulaz.*

This brings us round full circle, because *khulaz,* meaning hollow, is the original source for the Old German *hohl,* the Old English hollow, and the Modern English hole!*

Throughout this book we will see countless examples of Tolkien's endless fascination with obscure philological humour, but more importantly, these examples will also demonstrate how Tolkien's obsession with words was a constant source of creative inspiration for him. Words had an almost magical significance that suggested endless creative possibilities. Consequently, this book is primarily about words and language, and how they can provoke and inspire.

Centre: Bungo Baggins, architect of Bag End and father of Bilbo Baggins

* As if this were not complicated enough, Professor Tolkien added other factors: among Men and Elves, Hobbits were usually noted by their size (half human size, thus *halflings*) rather than by their holes.
Therefore: *Kuduk* (Hobbit) in Hobbitish translates as *Periannath* (Halfling-Folk) in Sindarin of Elves, which relates to *Periain* (Halfling) in Sindarin of Elves, which is *Banakil* (Halfling) in Westron of Men, and returns to Hobbit (Kuduk) in English.

II. *Dictionary* HOCUS~POCUS

In most dictionaries Tolkien's magic word Hobbit appears directly after the word Hoax, which was originally a shortened form of the magic word Hocus-Pocus. Interestingly enough, Hoax has come to mean "a trick, a practical joke, or fabricated tale."

This is not an accident. The story of *The Hobbit* is, after all, a fabricated tale that Tolkien went to great lengths to present as a translation of an ancient historic manuscript, rather than a novel. Clearly, he mischievously enjoyed the idea of creating an elaborate, extended literary hoax.

Indeed, after we exclude Tolkien's word Hobbit and look at the thirteen words that follow Hoax, from Hob to Hobo, it is easy to see that Tolkien was inspired by this simple list of words to shape almost every aspect of the Hobbit's character.

Tolkien's "discovery" of the Hobbit character through clues supplied by this list of words is typical of his creative logic and might be described as an elaborate and extended philological joke.

In fact, by saying "Hocus-Pocus" over the dictionary we find we can embark on an adventure that duplicates that of his novel with one Hobbit and thirteen Dwarves called Hob, Hobble, Hobbledehoy, Hobbler, Hobby, Hobbyhorse, Hobgoblin, Hobiler, Hobit, Hoblike, Hobnail, Hobnob, and Hobo.

All thirteen of these Dwarf-words have several meanings, and most are homonyms (words that sound alike but have different meanings and unrelated origins). However, whatever their nature, every one of these words has contributed to the creation and evolution of the Hobbit and his world.

If you doubt this, simply take a look at how the *Chambers Concise Dictionary*, for instance, currently defines Hobbit:

HOBBIT~One of a race of imaginary beings, half human size, hole-dwelling and hairy-footed, invented by J. R. R. Tolkien in his novel *The Hobbit,* 1937.

A race of imaginary beings: A Hob is a fairy, an elf, an imaginary being.
Half human size: A Hobbledehoy is a stripling, half-man and half-boy.
Hole-dwelling and hairy-footed: A Hob is a male ferret—a half-tame variety of polecat kept for driving rabbits from burrows. (That is, hairy-footed hole-dwellers who drive other hairy-footed hole-dwellers from their holes.)

If this isn't convincing, try to imagine almost everything you know about Hobbits and see if the thirteen words following Hoax don't have something to do with those characteristics. Let us take a look at these words and see what else they can tell us about our imaginary Hobbits.

The word Hob tells us Hobbits are hill-dwellers, hole-dwellers, and half human size.

Hill-dweller: Hob comes from the root word *hump,* originally Low German, meaning hill.
Hole-dweller: Hob is a spirit that builds its home in a hollow hill. Ancient round barrows are often called Hob's Houses.
Half human size: Hob or Hobmen is the generic name for various types of rather benign Hobs or Brownies; these are man-like, hairy, roughly three feet tall and hole-dwelling.

The words Hobnob, Hobbyhorse, and Hobble tell us Hobbits love to drink, gossip, dance, and tell riddles.

Love of drink and gossip: Hobnob means to drink and gossip together.
Love of dancing: Hobbyhorse is a medieval morris dancer.
Love of riddles: Hobble is to perplex.

The words Hoblike, Hobnail, Hobble, Hobbyhorse, and Hobby tell us Hobbits are comic, rustic, stubborn, whimsical, and eccentric.

Comic: Hoblike is clownish, boorish.
Rustic: Hobnail is a country clodhopper.
Stubborn: Hobble is to impede, to create difficulty.
Whimsical: Hobbyhorsical means whimsical, amusing.
Eccentric: Hobbyist is one committed to pleasurable, eccentric, and often pointless amateur activities.

Melilot Brandybuck

The words Hobby and Hobit also tell us Hobbits are keen-eyed marksmen with slings and arrows.

Keen-sighted, hawk-eyed: Hobby is from the French *hobet* and the Latin *hobetus,* meaning a small hunting falcon.
Excellent shot with stones: Hobit is a howitzer or catapult.
Excellent archers: Hobit is a catapult; linked to the Welsh *hobel,* meaning arrow.

The words Hobgoblin and Hobiler tell us Hobbits are Royalists and Elf-friends.

Elf-friend, Orc-enemy: Hobgoblin means literally an Elf (Hob)-Goblin (Orc).
Loyal Royalist Soldiers: Hobiler is a medieval light-armed militiaman sworn to the service of a king. He seldom fought in battles, but was often used to carry intelligence and reconnoitre.

The words Hobbiler, Hobbler, and Hob tell us Hobbits are farmers, rivermen, and woodsmen.

Harfoot Hobbits are farmers: Hobbiler is a feudal tenant farmer and soldier.
Stoor Hobbits are rivermen: Hobbler is someone who tows a vessel with a rope, either along a bank or with a rowboat.
Fallohide Hobbits are woodsmen: Hob or Hob-i-t'-hurst is a Brownie or Elf of the woods.

The word Hobo tells us Hobbits were once a wandering race of migrant farm workers.

Hobbits during Wandering Years: Hobo is "one who works and wanders."
Hobbit as tillers of the soil: Hobo originated as "Hoe Boy" or itinerant farm worker.

III. *Enter* BILBO BAGGINS

The first and original Hobbit created by J. R. R. Tolkien was a certain gentlehobbit by the name of Bilbo Baggins. We have examined the word Hobbit and observed what that word contributed to the race. Now let us examine the given names of the quintessential Hobbit, Mr. Bilbo Baggins, and see what they contribute to his character and his race.

First, let's take a look at the family name: *Baggins.*

BAGGINS → *afternoon tea, a substantial snack between meals*

We can see from the opening scenes of *The Hobbit* that Hobbits seem to like nothing better than snacking between meals; and they are especially addicted to extensive four o'clock teas. Did the name Baggins give Hobbits their habit of overeating? Or, was the name Baggins chosen because Hobbit eating habits were already known? It is one of those "chicken and egg" riddles. Whatever way around, it now seems it would be hard to find a better name for a Hobbit than Baggins. But, of course, that is not the end of it. The name Baggins either suggested or was chosen to emphasize the fact that Bilbo Baggins came from a well-to-do family. Just as Hobb(it) is a diminutive of Hob or Hobb, so Bagg(ins) is a diminutive of Bag or Bagg, the eponymous progenitor of the Baggins family.

Certainly, in British nomenclature, Baggins has its origin in the Middle English Somerset surname Bagg, meaning money-bag.

BAGG → *money-bag, pack, bundle*

The theme of "money-bag" is repeated in the name of Bilbo's father, Bungo Baggins. The root for Bungo is bung, which first entered the English language in 1566 as *bunge*, a purse, but by 1610 we are told, "Bung is now used for a pocket, heretofore for a purse." Furthermore, we can deduce that Bungo's purse was substantial, for with its contents Bungo built the great manor of Bag End, and had enough for his son Bilbo to be more than comfortable.

Now let us look at our hero's first name: Bilbo.

BILBO → *short sword or rapier*

The word *bilbo* came to English in the fifteenth century through the name Balboa, a Portuguese city once renowned for the making of delicate swords

(Bilbo) Baggins the Hero.
(Bilbo) Baggins the Bourgeois
Bungher
Burglar
Baggage Man
Bag Man → (Bilbo)

of flexible, but almost unbreakable, steel. In Shakespearean times, a bilbo was a short but deadly piercing sword, a small thrusting rapier.

This is an excellent description of Bilbo's sword, the charmed Elf knife called Sting. Found in a Troll hoard, Bilbo's bilbo was forged by the ancient Elven smith Telchar and gave off a blue light in the presence of evil. It had a charmed Elven blade that could pierce through armour or animal hide that would break any other sword.

The name Bilbo apparently immediately suggested certain actions in the plot to Tolkien, because in the first draft of *The Hobbit* we find that Bilbo's bilbo, Sting, is the instrument of the Dragon's destruction when it is thrust into the small unarmoured spot in the monster's belly.

Although this plot was abandoned in the final version of *The Hobbit*, the weapon proved critical to the plot of the *The Lord of the Rings*, when another Hobbit (Samwise Gamgee) uses Sting to deliver a mortal blow by piercing the belly of the monstrous spider, Shelob the Great.

In *The Hobbit*, however, it was sharp wit rather than a sharp sword that gave Bilbo the edge. Whether to escape from Orcs, Elves, Gollum, or the Dragon, Bilbo's wits allowed him to solve riddles and trick villains. In the end, the Dragon's downfall came through Bilbo exploiting the monster's vanity by means of a "sting," or confidence trick, that resulted in the discovery of how the Dragon might be slain.

When we put the two names together—Bilbo Baggins—we have two aspects of our hero's character, and to some degree the character of Hobbits in general. On the face of it, the name Baggins suggests a harmless, well-to-do, contented character; while the name Bilbo suggests an individual who is sharp, intelligent, and even a little dangerous.

Superficially and initially, Bilbo Baggins is presented as a mildly comic, home-loving, rustic, middle-class gentlehobbit. He is harmless and obsequious, full of gossip, homely wisdom, wordy euphemisms, and elaborate family histories. He is largely concerned with home comforts, village fêtes, dinner parties, flower gardens, vegetable plots, and grain harvests.

Bilbo Baggins is a comic antihero who goes off on a journey into a world where the commonplace knocks up against the heroic. One has to see that values are different in these worlds. In Bilbo Baggins we have a character with modern everyday sensibilities that the reader may identify with while having an adventure in an ancient, heroic world.

However, there is something different and contrary about Bilbo Baggins's nature: he is a typical Hobbit full of practical common sense, but he has a cutting edge. That is the reason he was chosen by Gandalf the Magician to be hired out as a freelance "hero-burglar" by the Dwarves on their Quest.

EPIC VERSUS EVERYDAY:
HERO → *Burglar*
BURGLAR → *Criminal in everyday society*
BURGLAR → *Hero in epic society*

Why was it thought that Bilbo Baggins would make a good burglar to assist the Dwarves in the theft of the Dragon's treasure?

Here we have Tolkien involved in wordplay again: Bilbo Baggins was a burgher who became a burglar. Burgher was a freeman of a burgh or borough (or in the case of Hobbits, a burrow), which certainly applied to Bilbo Baggins. Even more, its derivative Bourgeois described a person with humdrum middle-class ideas.

The Germanic root word *burg* means "mound, fort, stockaded house."

BURGHER → *one who owns a house*
BURGLAR → *one who plunders a house*

So, we have the everyday humdrum middle-class burgher entering an epic world and being transformed into his opposite, a burglar.

Even so, we are not quite through. There are still other links in underworld jargon between Bagg and Baggins and the words bag and baggage as used by working criminals in Britain. Three are quite notable: to bag means to capture, to acquire or to steal; a baggage man is the outlaw who carries off the loot or booty; and a bag man is the man who collects and distributes money on behalf of others by dishonest means, or for dishonest purposes.

It appears that Tolkien's choice of names for his Hobbit hero not only helped to create the character of Bilbo Baggins, but also went a long way toward plotting the adventure his hero embarked on.

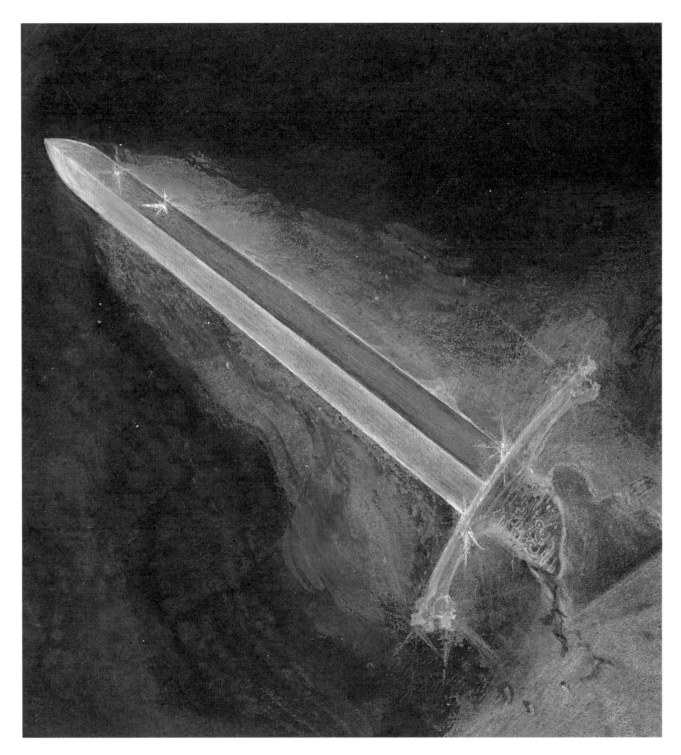

For in *The Hobbit* we find Bilbo Baggins the burglar is hired by the Dwarves to bag the Dragon's treasure. He then becomes the baggage man who carries off the loot. However, after the death of the Dragon and because of a dispute after the Battle of Five Armies, Bilbo Baggins becomes the bag man who collects the whole treasure together and distributes it among the victors.

(BILBO) BAGGINS THE BOURGEOIS → *Burgher* → *Burglar* → *Baggage Man*
→ *Bag Man* → (BILBO) BAGGINS THE HERO

What is in a name? In the name Baggins we have a Baggins who was a borough-burrow-dwelling bourgeois burgher who, by hiring himself out as a professional burglar, baggage man, and bag man, became that most un-Hobbitish of creatures: a hero.

IV. Gollum & the Goblins

"Once there was a Goblin living in a hole." So begins a little song in a story that J. R. R. Tolkien read as a child. It quite obviously resonated in his mind because several decades later Tolkien wrote about another diminutive hole-dwelling creature in the famous first line of his first novel: "In a hole in the ground there lived a hobbit."

The story is *The Princess and the Goblin** by George MacDonald. It was published in 1872, and is largely concerned with conflicts between diminutive Miners and Goblins in under-ground tunnels, which strongly foreshadowed subterranean skirmishes between Tolkien's Hobbits and Goblins.

HOBBITS *and* GOBLINS *appear to have occupied the same hole.*

In Tolkien's story oversized Hobbit feet are important. In MacDonald's story oversized Goblin feet are important—but for different reasons. Tolkien's Hobbit feet are seen as a strong and positive characteristic. MacDonald's Goblins' feet are their only weakness, and the Miners defeat the Goblins by stamping on their feet and singing magic spells. In Tolkien's story Goblins could be repelled by certain spells, but their feet were iron shod. It was the Hobbits who went barefoot.

HOBBITS *and* GOBLINS *appear to have been preoccupied with feet.*

However, in MacDonald's story, we have the rhyme: "Once there was a goblin living in a hole: busy he was cobblin' a shoe without a sole."

This rhyme is a kind of riddle—and one worthy of a Hobbit, at that.

RIDDLE: *Why does the Goblin make a shoe without a sole?*

ANSWER: *Because the Goblin is a creature without a soul!*

Tolkien's Goblins are protected by iron-shod shoes, but they share MacDonald's Goblins' *soulless* condition; while Tolkien's barefoot Hobbits share MacDonald's Goblins' *soleless* condition.**

HOBBIT + GOBLIN → HOBGOBLIN

Hobgoblin—one of the thirteen magic words from our Hocus-Pocus Dictionary—was critical to the evolution of the Hobbit as a species, and to the development of *The Hobbit* as a novel. Hobbit is a diminutive form of the root word Hob. Hobgoblin is a composite word:

HOB~*a benevolent spirit*
GOBLIN~*an evil spirit*

The resulting Hobgoblin is usually a mischievous creature: either a rather warped good spirit, or a somewhat redeemed evil spirit. Either way, a Hobgoblin is an ambivalent creature, frequently at odds with human justice.

* Curiously, MacDonald uses the terms Goblin, Hob, and even Cob interchangeably. (Cob from the German *kobold*, Goblin from the Latin *gobelinus*—the source of the English goblin—and Hob from the English hobgoblin.)

** This foot obsession was a long-standing one. Curiously enough, the first poem known to have been published by Tolkien as a teenage student in 1915 at Oxford was entitled "Goblin Feet." Furthermore, it would be difficult to reject MacDonald's influence, for late in life Tolkien wrote (in a letter) that his Goblins were in the MacDonald tradition: "except for the soft feet, which I never did believe in."

More importantly, Hobgoblin is a statement of opposites, and this was the spark that ignited the dramatic tension in Professor Tolkien's novels.

In Hobgoblin, we have a word that embodies the struggle between the forces of good and evil. In Tolkien's novels, with Hobbit and Goblin we have two diminutive, hole-dwelling races that embody the struggle between the forces of good and evil. Hobgoblin is the magic word that imaginatively links Hobbit (a diminutive of Hob) with Goblin, but there was at least one other link that makes the reader realize that—creatively—Hobbit and Goblin emerged from the same hole.

GOLLUM AS A HOBGOBLIN

Smeagol Gollum was a Hobgoblin, wherein Goblin overwhelmed the Hobbit.

IF BILBO BAGGINS IS THE ORIGINAL HOBBIT, THEN SMEAGOL GOLLUM IS THE ANTI-HOBBIT.

In the beginning, Gollum was given the name Smeagol. He was a Hobbit and his name largely defined his nature, as it meant "burrowing, worming in." He was possessed by a restless, inquiring nature. He was always searching, and digging among the roots of things; burrowing, but also twisting and turning, this way and that.

ENGLISH~*Smial** → *burrow*
OLD ENGLISH~*Smygel* → *Smeagol* →
burrowing, worming in
HOBBITISH~*Tran* → *burrow* → *Rhovenian*
trahan → *Trahald* → *burrowing, worming in*

Smeagol lived east of the Misty Mountains in the ancient, ancestral river valley homeland of the Stoorish Hobbits. There Smeagol often fished and explored with his cousin Deagol. It was this cousin, Deagol, who first discovered the Dark Lord's Ring on the river bottom. Immediately Smeagol was seized by avarice. He murdered Deagol and stole the One Ring.

ENGLISH~*Dial*** → *secret*
OLD ENGLISH~*dygel* → *Deagol* → *secret,*
hiding away

HOBBITISH~*Nah* → *secret* → *Rhovenian nahan*
→ *Nahald* → *secret, hiding away*

GOLLUM'S SECRET

Deagol's name literally meant "secret." This was doubly appropriate as the cursed Smeagol always insisted on his ownership of the Ring. His darkest secret was that he had acquired the Ring only through murder and theft. Guilt and fear that someone might discover his secret and take the Ring from him so terrified Smeagol that he hid himself away, "burrowing and worming in" beneath the roots of the Misty Mountains.

SMEAGOL AS GOLLUM

The evil power of the Ring lengthened Smeagol's miserable life for centuries, yet it warped him beyond recognition. Thereafter he was called Gollum because of the nasty guttural sounds he made when he spoke. Gollum became a murderous ghoul and cannibal who shunned light and found grim solace in dark caverns and dank pools.

GOLLUM AS HOBGOBLIN

Smeagol Gollum was a Hobgoblin that became almost purely a Goblin or, to use Tolkien's term, *Orc*. Indeed, Tolkien's drafts tell us that for some time after writing *The Hobbit* the author was not sure whether Gollum was some form of Orc or some form of Hobbit.

GOLLUM AS ORNACEA

Tolkien decided on Hobbit, but in many ways Gollum was Orkish, with specific reference to the evil demons known in Anglo-Saxon texts (especially *Beowulf*) as the Ornacea, meaning "walking corpse." Truly Gollum was one of the living dead or a "walking corpse," animated by a sorcerous power of the Ring.

GOLLUM THE GOLEM

In this undead state Gollum also resembled the Golem, according to legend a massive and vengeful "Frankenstein monster," who was made of clay and animated by a Jewish sorcerer's spell to destroy the enemies of the Jews of Prague, but who eventually turned into a hateful destroyer of all life.

* **Smial is pronounced Smile; ** Dial also rhymes with Smile.**

→ *Hobbit* → *Smeagol* → *Ghoul* → *Hobgoblin* → *Goblin* → *Orc* → *Ornacea*

Hobgoblin → *Goblin* → *Orc* → *Ornacea* → "*Walking corpse*" → *Golem* → *Gollum*

"Walking corpse" → Golem → Gollum → Hobbit → Smeagol → Ghoul → Hobgoblin → Goblin → Orc → Ornacea → "Walking corpse" → Golem → Gollum → Hobbit → Smeagol → Ghoul → Hobgoblin → Goblin → Orc → Ornacea →

v. Hobbit
Heritage & History

If we look at the evolution and history of the Hobbit races and the Anglo-Saxon tribes, we see an obvious pattern. The origins of both are lost in the mists of time somewhere beyond a distant and massive eastern range of mountains. The ancestors of both the Hobbits and the Anglo-Saxons migrated across these mountains and eventually settled in a fertile river-delta region.

Eventually war and invaders forced the Hobbits to leave their second homeland known as the Angle—a wedge of land between the Loudwater and Hoarwell Rivers—and migrate across the Brandywine River into what eventually became known as the Shire of Middle-earth.

Similarly, war and invaders forced the Anglo-Saxons to leave their homeland known as the Angle—a wedge of land between the Schlei River and Flensburg Fjord—and migrate across the English Channel into what eventually became known as the Shires of England.

Furthermore, there were three breeds or tribes of Hobbits: Fallohides, Stoors, and Harfoots; which are directly comparable to the three races or tribes of English: Saxons, Angles, and Jutes.

Finally, we find the Hobbit founders of the Shire were the brothers Marcho and Blanco; while the Anglo-Saxon founders of England were the brothers Hengist and Horsa.

Anglo-Saxons

MIGRATION *from original homeland* EAST OF THE ALPINE MOUNTAINS. WEST *to a wedge of river-delta land called the* ANGLE. *Then* WEST *again to a new homeland called the* SHIRES. *Founders of the Shires known as* HENGIST *and* HORSA. *Original three tribes of Anglo-Saxons:* ANGLES, SAXONS, *and* JUTES.

Hobbits

MIGRATION *from original homeland* EAST OF THE MISTY MOUNTAINS. WEST *to a wedge of river-delta land called the* ANGLE. *Then* WEST *again to a new homeland called the* SHIRE. *Founders of the Shire known as* MARCHO *and* BLANCO. *Original three tribes of Hobbits:* FALLOHIDES, STOORS, *and* HARFOOTS.

Hengist in Old English → Horse (Stallion)
Horsa in Old English → Horse

Marcho → Horse
→ *March in Welsh*
→ *Marc in Gaelic*
→ *Mearh in Old English* *

Blanco → Horse (White)
→ *Blanca in Old English*
→ *Blakkr in Old Norse*

Breeds or Strains of Hobbits

Like the Anglo-Saxon tribes, all Hobbits shared certain characteristics. Just as we have seen how the elements and associations with the word Hobbit went into the shaping of the racial and individual characteristics of Hobbits, so the tribal names Harfoot, Fallohide, and Stoor contributed to the development of Hobbits and their world.

Harfoots

The Harfoots are the smallest and most typical Hobbits: the standard-issue diminutive, brown-skinned, curly-headed, hairy-footed, hole-dwelling Hobbit. Harfoots have always made up the majority of the total Hobbit population. They are extremely conservative in their habits and are the least

adventurous of Hobbits, although they are known to have had some commerce with itinerant bands of Dwarves. They delight in the peace and quiet of country life, especially hillsides, farmlands, and pastures. Harfoots are naturally gifted farmers and gardeners.

Harfoot is an excellent and highly descriptive name for this most typical of Hobbits, and originally was applied to all Hobbits. Harfoot is an English surname, derived from an Old English epithet or nickname meaning Hare-foot. This was not an uncommon nickname among Anglo-Saxons and usually meant "fast runner" or "as nimble as a hare."

This is an accurate enough description of Hobbit behaviour, but it is also meant as an obvious joke: a pun, or play on the words hare and hair.

For, besides being naturally fast and nimble on their feet, Hobbits are also both hare-footed and hair-footed. That is, like the hare, the Hobbit has feet that are both large and hairy.

Harfoot breed of Hobbit
Harfoot~English surname
Hare-foot~Anglo-Saxon epithet or nickname
Usually means fast runner or nimble as a hare

Hobbitish Punning Joke
Harfoot → *Hare-foot* → *Hair-foot*

Harfoot/Harefoot/Hairfoot
Succinct description of Hobbits. (That is, small and nimble creatures with large, hairy feet.)

Typical Harfoot Names: Brown and Brownlock are descriptive of the hair and skin colour of Harfoots. Other names such as Sandheaver, Tunnelly, and Burrows suggest the construction of hole-dwelling Harfoot Hobbit homes. Names such as Gardner, Hayward, and Roper tell us of typical Harfoot occupations.

Fallohides

Fallohide is the name of the second strain, or breed, of Hobbits. They are woodland dwellers in origin, and the least numerous of the breeds. The most unconventional and adventurous of Hobbits,

(* Old English *Mearh* evolved into the Modern English *Mare*. On Middle-earth, *Mearh* was Tolkien's source of inspiration for the Mearas, that race of white horses of the Riders of the Mark or the March—meaning Borderland.)

they are the most likely to consort with Elves. They have the fairest skin and hair of the three, and are generally taller and thinner than their cousins.

The name for the Fallohide breed of Hobbit can be understood in terms of Falo-Hide: Falo as in the Old High German for pale yellow or reddish yellow, that is the colour of a fallow deer; and Hide as in skin or pelt. This interpretation could reasonably be used to describe the fair-haired, pale-skinned Fallohide breed.

Another explanation of Fallohide is suggested from different root words. Fallow-Hide: Fallow as in Old English for "newly ploughed land;" and Hide as in keeping out of sight, hiding away in secret. Hide is also an ancient measurement of land sufficient for a household—about one hundred acres.

It is likely that both interpretations are meant to be applied simultaneously. The second suggests characteristics shared by all Hobbits: a love of newly tilled land and an uncanny ability to hide away in the landscape, so as to appear almost invisible to Humans. The first gives us the physical clues that differentiate the Fallohides from other Hobbits. Furthermore, with the name Fallohide, one cannot help but think there is something of a playful nature going on with "Follow and Hide," as in the game of "Hide and Seek."

FALLOHIDE BREED OF HOBBIT FALO-HIDE
Falo~Old High German: *pale yellow*
Hide~English: *skin or pelt*

FALLOW HIDE
Fallow~Old English: *ploughed land*
Hide~Old English: *measure of land*

FOLLOW-HIDE
Hobbitish Joke~Game of Hide and Seek

TYPICAL FALLOHIDE NAMES: The fair-haired Fallohides are suggested by many family names such as Fairbairn, Goold, and Goldworthy. Their unconventional and independent nature and their intelligence are suggested by names such as Headstrong and Boffin.

STOORS

Stoors are the largest and strongest of Hobbits and the most like Humans. They tend to live on river-bottom land and marshes. They are quite un-Hobbit-like in their occasional use of footwear that takes the form of Dwarf boots. Also, much to the amazement of the other Hobbits, some Stoors are actually capable of growing hair upon their faces, though nothing so luxuriant as the beards of Humans and Dwarves.

Stoor appears to be derived from the Middle English *stur* and the Old English *stor,* meaning hard or strong. This is appropriate in differentiating the larger and stronger Stoor from the shorter Harfoots and the slighter Fallohides.

STOOR
→ *Stur (Middle English)*
→ *Stor (Old English)*
→ *Strong (Modern English)*

Stoors as a breed of Hobbits are distinctive in their appearance, their habitat, and also their occupations. Stoors distinguish themselves among Hobbits by being fearless of water and by being the only breed that even considers the idea of swimming or boating. By being adapted to water and boats, they become wealthy in trading and shipping goods for other Hobbits, and trade with many nations of Men on Middle-earth.

Like all Hobbits, Stoors are hoarders who never throw anything away. Consequently, the name Stoor is a clever intentional pun suggestive of this characteristic. These Hobbits "stoor" or "store" goods away. But, more specifically, they are Stoors or Stowers: those who stow or pack away goods, especially on boats. Many of the Stoors are Stowers on boats and warehouses in Bucklebury. Some are ship-chandlers and merchants who also run Stores.

STOOR → *Stower* → *Store*

As pointed out when discussing words associated with Hobbit, there are two types of Hobblers among Hobbits. The Harfoots and Fallohides were associated with the first type of feudal Hobblers or Hobilers—tenant farmers who serve in the voluntary militia in time of war; while the Stoors are associated with river or canal Hobblers—workers who often tow river barges with ropes by walking along the bank or from rowing boats.

TYPICAL STOOR NAMES: Puddifoot is an archetypical Stoorish name for it suggests "puddle-foot" or someone who enjoys splashing around in water. However, as an English surname, it was originally Puddephat (or Pudding Vat, otherwise known as Bulgy Barrel), meaning a man with a fat belly. So we get all the Stoorish images at once: large, fat, big-footed, and water-loving.

Banks appears to be a Stoorish name for Hobbits who liked to live on river banks. Other names like Cotton, Cottar, and Cotman may have been Stoorish names in origin because they all mean "Cottager;" and the Stoors were the first Hobbits to emerge from their holes and live in houses.

Three breeds or tribes of Hobbits:
HARFOOTS~FALLOHIDES~STOORS

Each race was allied with another people:
DWARVES~ELVES~MEN

Linguistically each borrowed from men:
NORSEMEN~CELTS~ROMANS

Each breed was allied with an English tribe:
SAXONS~ANGLES~JUTES

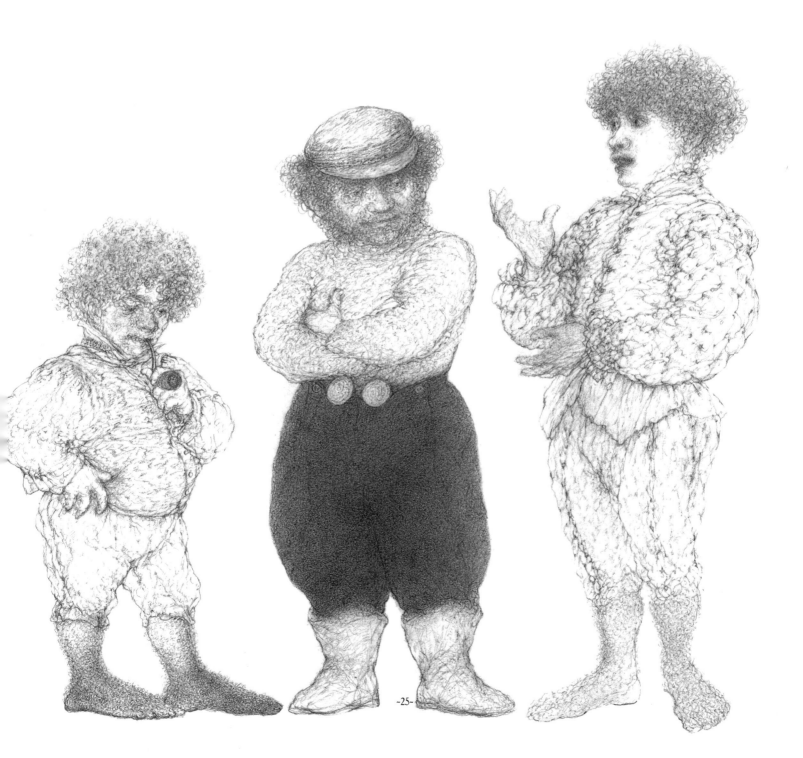

VI. ANCESTORS & Founding Fathers

After the founders of the Shire, Marcho and Blanco, the earliest recorded Hobbit was Bucca of the Marish. By general acclaim, Bucca of the Marish was the first Thain of the Shire and commander of the Hobbitry-at-Arms. The title was hereditary, and for nearly four centuries all subsequent Thains were directly descended from Bucca of the Marish.*

Bucca of the Marish was also the founder of the first great Hobbit family dynasty, the Oldbucks. Indeed, the Oldbucks were the first Hobbits to use surnames or family names at all.

The name Oldbuck came about simply enough. As Bucca lived into considerable old age, he became affectionately known as Old Buck. In time, the names Old Buck and Thain were so often used interchangeably that Old Buck became as much a title as Thain. In generations to follow, all Bucca's descendants used the term Oldbuck to honour both him and the ruling Thain of the day.

(* In early English history, the title and position of Thane was an almost exact parallel to Thain of the Hobbits. Similarly, the Thane was ranked in a class of gentry between ordinary freemen and hereditary nobles.)

THAIN ⇒ *Bucca* → *Old Bucca* → *Old Buck* → *Oldbuck* ⇒ THAIN

However, Hobbit humour being what it is, a linguistic joke had to be built into this tale of Old Buck's descendants. It is quite logical that the oldest and most gentrified Hobbit family became known as the Oldbucks. After all, it is common knowledge that established gentry in most societies are inevitably known as Old Money; that is, Old Money meaning Old Dollars meaning Old Bucks.

OLDBUCKS ⇒ *Old Money* → *Old Dollars* → *Old Bucks* ⇒ OLDBUCKS

While Bucca of the Marish was the source of the name Oldbuck, or Zaragamba (in original Hobbitish), it would eventually evolve into the even more famous family name Brandybuck, or Brandagamba (in original Hobbitish).

OLDBUCK (translated Hobbitish)
Zaragamba (original Hobbitish) → *Zara* (old) + *Gamba* (buck)

BRANDYBUCK (translated Hobbitish)
Brandagamba (original Hobbitish) → *Branda* (border) + *Gamba* (buck)

How did this happen?

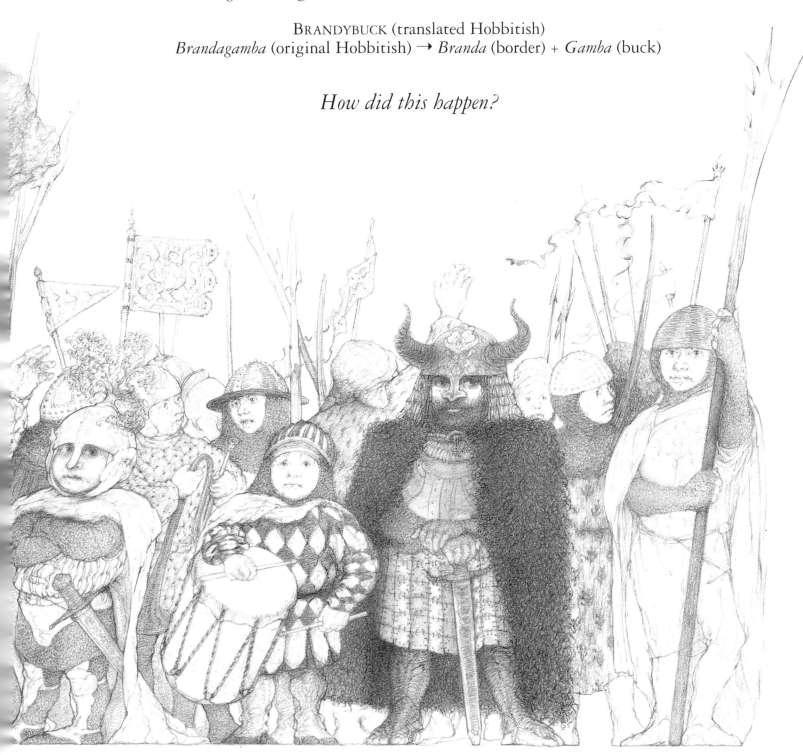

VII. *Buckland &* BRANDY HALL

Seven centuries after the Shire's founding, the Twelfth Thain of the Shire, Gorhendad Oldbuck, abandoned his title and the Oldbuck folklands of the Marish. He led his people east of the Shire across the Brandywine River ("border river") to pioneer and settle in a new, fertile land. Gorhendad Oldbuck soon established the new folkland and named it Buckland—or "Bucca's land"—after the family's eponymous ancestor.*

On Buck Hill on the banks of the Brandywine River, Gorhendad Oldbuck had the new family mansion built. This became known as Brandy Hall and Gorhendad was soon known as the Master of Buckland. He was also the founder of a new dynasty; for after the establishment of Buckland, the Oldbuck (or Zaragamba in Hobbitish) family name was changed to Brandybuck (or Brandagamba in Hobbitish).

BRANDYBUCK FAMILY

The name of Brandybuck shaped the character of the family to a considerable degree. All of the Brandybucks were, on the one hand, admired for their leadership qualities, high spirits, and strong wills; on the other hand, they were criticized by (less bold) Hobbits for what was considered their rather wild and reckless nature.

BRANDY~*Strong Spirit; from "firebrand"*
BUCK~*Stag, as in the leader of a herd of deer; but also Stag as in wild young man, or "young blood"*

There is no doubt of the Buckish nature of the Brandybucks. They are just the sort of high-spirited Hobbits who might order a few drams of brandy during an evening of hobnobbing.

They were also thought to be reckless because they lived beyond the borders of polite Shire society. They fearlessly crossed the "border-waters" of the Brandywine River and settled in the wild "borderlands" of Buckland.

BUCKLAND AND BUCKINGHAMSHIRE

There are etymological connections between Hobbitish Buckland and England's historic and geographic Buckinghamshire:

BUCKLAND *in the Shire* →
BUCKINGHAMSHIRE *in England*

Bucca was the early Hobbit founder of Buckland in the Shire; Bucca was the Anglo-Saxon founder of Buckinghamshire.

BUCCA *was an Old Hobbitish name meaning stag or ram*
BUCCA *was an Old English surname meaning stag or ram*

(* Gorhendad: As he was the First of the Brandybucks and First Master of Buckland, the name Gorhendad seems appropriate. It means "great-grandfather" in Welsh—literally "gor-hen-dad" or "over-old-father". Among Hobbits, it may actually have been a title rather than a proper name, meaning Forefather of the Brandybucks.)

Bucca is a name that appears in various permutations in the histories of Britain and the Hobbit lands of the Shire. Bucca has proved to be an appropriate name for the leader of a tribe, as a stag is the leader of a herd of deer, and a ram is the leader of a flock of sheep.

The Hobbitish Bucca of the Marish has left his name scattered across the Shire: Buckland, Buck Hill, Brandybuck Hall, Bucklebury, etc. Similarly, there are scores of Old English place names that relate back to the eponymous Anglo-Saxon chieftain, Bucca: Buckingham meaning a river meadow of Bucca's followers; Buckminster meaning Bucca's church; Bucknall meaning Bucca's nook; Bucknill meaning Bucca's hill; and Buckton meaning Bucca's farm.

BUCKLAND AND BOOKLAND

Curiously, although the historic Buckinghamshire has a similar background to the Hobbitish Buckland, the historical English name Buckland does not have anything to do with an old Anglo-Saxon chieftain named Bucca.

Boc (Old English) → Buck
(Middle English) → Book

In the real historic and geographic Britain, "Buckland" usually means Bookland; that is, Book-land or "land held by charter" from the church or the royal family. There are over two dozen Bucklands in England (mostly in the south), all of which are lands of the Book. None is concerned with any man named Bucca, nor any Buck meaning stag or ram.

BUCKLAND →
BOOKLAND →
CHARTERLAND
"Buckland" usually means Bookland; that is, Book-land or "land held by charter" from the church or the royal family.

BUCKLAND AND FANTASYLAND

However, Buckland and the whole of the Shire were Booklands in that they were occupied by Hobbits through a charter granted to them by the High Kings of the North.

Also, in another sense, Buckland and the Shire and all of Middle-earth are Booklands, in that they are fictional lands created entirely by J. R. R. Tolkien in his books.

BUCKLAND → BOOKLAND → FANTASYLAND

BRANDY HALL

The first Master of Buckland, Gorhendad Brandybuck, was also known as Master of the Hall because he was the architect of Brandy Hall, the most impressive single residence in Buckland.

This Hobbit mansion had three massive front doors and twenty lesser doors in the many-levelled escarpment gouged out of the ridge of Buck Hill above the Brandywine River. It was the home of more than two hundred members of the Brandybuck family.

Travellers to the Shire who took the ferry across the Brandywine River at dusk were sometimes startled by the sight of the dark west face of Buck Hill unexpectedly being transformed into a mass of gold. In fact, this shimmering gold wall above the river was the setting sun reflecting in the hundred round windows of Brandy Hall.

Although the Master of Buckland lived at Brandy Hall, this was not the exact site of the principal township of Bucklebury. Brandy Hall was excavated out of the west face of Buck Hill above the river. The shops and houses of Bucklebury were actually on the flank of Buck Hill, just to the east of Brandy Hall. There were other towns in Buckland, such as Newbury, Standelf, and Haysend, but Bucklebury was the largest.

BRANDYWINE RIVER

In English the name of the river can be translated as Golden Brown River or Border River or Brandywine River. However, its origin is in the Elvish.

→ BARANDUIN RIVER~*Elvish* baran, *meaning golden brown* + duin, *meaning large. (Simple description of a large golden brown river.)*

→ BRANDA-NIN~*Hobbitish* branda, *meaning border* + nin, *meaning water (Hobbit misreading of Elvish changed meaning to border-river or river that marks the border of the Shire.)*

→ BRALDA-HIM~*Hobbitish* bralda, *meaning heady* + him, *meaning ale (Hobbit joke: pun on border, which becomes a river of brandy because of its frothy brown colour.)*

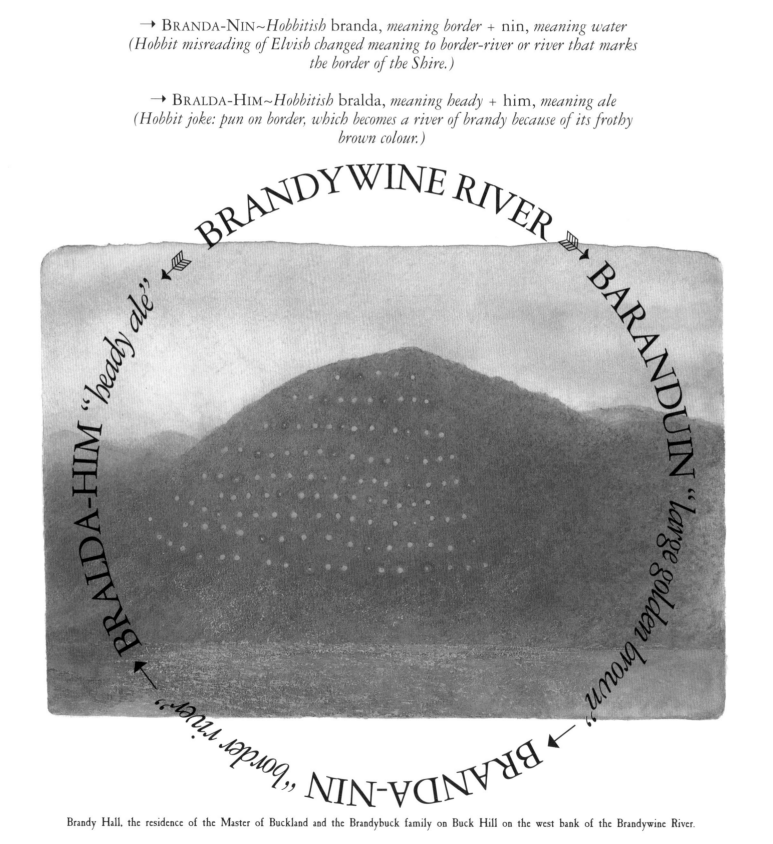

Brandy Hall, the residence of the Master of Buckland and the Brandybuck family on Buck Hill on the west bank of the Brandywine River.

VIII. TOOKLAND
& the Great Smials

*After the migration of the Oldbucks east of the Brandywine River, and the founding
of Buckland, a forceful new leader appeared among the Hobbits of the Shire. His
name was Isumbras Took. Appropriately, Isumbras is an Old English name meaning
Iron Arm (isen~iron, bras~arm). He was soon acclaimed Isumbras I, the
Thirteenth Thain of the Shire, and the First Thain of the Took line.
With the transfer of the Thainship to the Took family, the Fallohidish Tooks became
the most important family in the Shire. For centuries thereafter, the Thainship
became synonymous with the head of the Took clan. Hobbits used the terms Thain
and Old Took interchangeably.*

*Great Smials → Tuckborough → Tookland
→ Took → Tûk → Tuck*
TUCCA

BUCCA
*→ Buck → Oldbuck → Brandybuck
→ Buckland → Bucklebury → Brandy Hall*

ORIGIN OF THE TOOKS

Tolkien does not give us the name of the founder of Tookland and the progenitor of the Took family. However, if one looks at the genealogy of Bucca as the progenitor of the Oldbucks and Brandybucks, we can do a little linguistic detective work and soon discover the answer.

Tolkien gives us clues. We are told that the Great Smials of Tuckborough in Tookland were the seat of the Took family and that an earlier version of this name was Tûk. If we compare this progression to Brandy Hall of Bucklebury in Buckland as the seat of the Brandybuck family, and the earlier name Oldbuck, we can see that there is a parallel development. Just as the founder of the Brandybuck/Oldbuck family was Buck or Bucca, so the founder of the Took/Tûk family must be Tuck or Tucca.

Indeed, it seems to be quite logical that the eponymous progenitors of these dynasties were originally brothers: Bucca and Tucca of the Marish, after whom Buckland and Tookland were named.

FAMILY OF TOOKS

The Hobbit name of Tucca/Tûk/Tuck/Took itself has contributed much to the characteristics of a family notable for its bold Fallohidish nature and larger-than-life personalities. If we look at the descendants of Old Tucca it becomes clear that the characteristics came with the Took name.

As English surnames, Took and Tuck stem from Old Norse names suggestive of Thunder. They are both diminutive forms of the rather ferocious Old Norse Thorkil or Thurkettle. The English word *took*, as the past tense of *take*, is also suitably bold and direct. It, too, comes from an Old Norse source, *taka* meaning to seize, but came to modern English through the Old English *tucian*, meaning to disturb or afflict.

<div align="center">

TOOK AND TUCK:
English surnames of Old Norse origin

~*Diminutive of* THORKIL~
THOR'S HILL *or* THUNDER HILL,
that is, the thunder god's hill

~*Diminutive of* THURKETTLE~
THOR'S KETTLE *or* THUNDER CAULDRON,
that is, the thunder god's sacrificial cauldron

</div>

However, Tucca/Tûk/Tuck/Took also has its softer side. The names Took and Tuck have a more homely, Hobbitish nature built into them as well. Just as we have discovered that Baggins meant "substantial snack, afternoon tea," we find a similar meaning for the Took/Tuck family. (They were, after all, related; and the Tooks and Bagginses would often "tuck into a tea" together.) Tuck is defined as "food, eatables; especially cakes and sweets." Thus we have *tucker*, which is Australian slang for food in general; and *tuck shop*, meaning a sweet or cake shop on school premises.

This meaning of the name Tuck is the probable reasoning behind the name of that famous fat character, known as Friar Tuck, in the legend of Robin Hood. Indeed, with his cheerful manner, rotund shape, and large appetite, Friar Tuck would have made an admirable Tookish Hobbit, had he been about half his actual height. Added to everything else, both the Friar and the Took Hobbits were noted as crack shots with a bow and arrow.

GREAT SMIALS OF TUCKBOROUGH

At the end of the first millennium, after the Shire's founding, Isengrim II, the Twenty-second Thain, and the Tenth Thain of the Took line, began the Took clan's excavations beneath the Green Hills of Tookland.

These excavations, known as the Great Smials, were dug deep into the high and undulating escarpment of the Green Hills. Below the Smials, along the base of the massive tunnel-riddled rampart, is the rest of Tuckborough, the largest settlement in the Shire.

Isengrim, meaning Fierce Iron (*isen*—iron, plus *grim*—fierce), was an appropriate name for the chief architect of the Great Smials of Tuckborough. It is possible that Isengrim II spent too much time hobnobbing with Dwarves, for his imagination appears to have been inflamed by ambitions that were far beyond what was right and proper for a sensible Hobbit.

Perhaps it was the Took name itself that inspired Isengrim. These Great Smials of Tuckborough might well be described as a Tookish "thunder god's cauldron" built into the cliff face of a Tookish "thunder god's hill."

The Great Smials are certainly the closest that Hobbits ever came to monumental architecture. They constitute the primary home of the Took clan, and the Tooks are certainly the largest, wealthiest, and most ostentatious Hobbit family in the Shire.

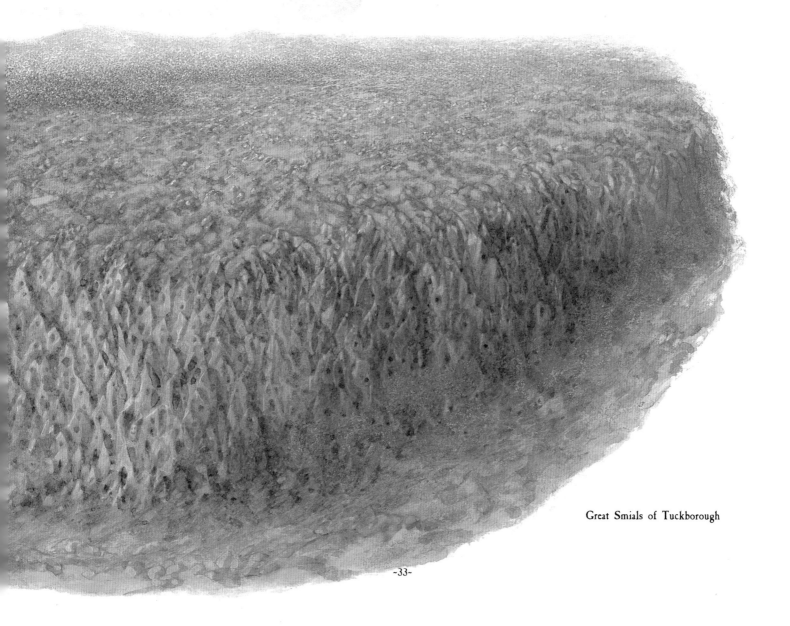

Great Smials of Tuckborough

IX. HOBBITS & *the Land*

Hobbits are the SPIRITUS MUNDI *of England. They are meant by Tolkien to be the Anglo-Saxon earth spirits who are most in touch with the land itself. They literally live in the earth, and in so many ways are meant to define the essential elements of Englishness.*

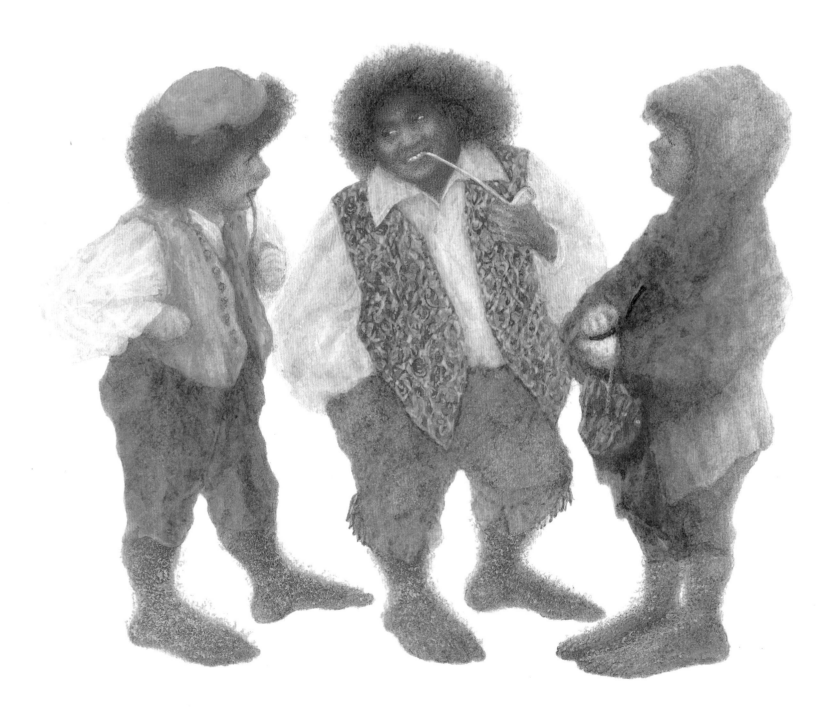

Hobbits are, after all, the holbytla (hole-builders and hole-dwellers), so it is logical that their first instinct is to work on the land. From their ground-level existence Hobbits have a profound understanding of plant and animal life. They can grow almost anything on farms and in orchards and gardens under conditions that humans would not even attempt to grapple with.

It is not surprising, then, that one of the most famous figures in Hobbit history was a horticulturist. A thousand years after the founding of the shire the most famous of Hobbit farmers, Tobold Hornblower of Longbottom, succeeded in perfecting the cultivation and curing of that ancient plant known as sweet galenas.

The galena is a smoking herb akin to the modern *nicotiana,* or tobacco plant, but apparently devoid of the unwholesome and poisonous aspects of modern tobacco. Popularly known as pipeweed, Old Toby Hornblower's discovery was the beginning of an industry and tradition of which the Hobbits were proud inventors and most dedicated practitioners.

After Old Buck and Old Took, Old Toby is the most famous ancestral Hobbit in their early history. The name, of course, is a typical Tolkien jest: he is suggesting that our word tobacco originated in the name Old Toby, the Hobbit who originated the practice of smoking.

Old Toby, or Tobold Hornblower
→ TOBACCO

Other aspects of his name also suggest his fame and occupation. Tobold comes from the original name Theobold, meaning Bold Person; or literally it suggests "Too-bold," a character larger than life. His second name suggests something similar about a vain and famous person, but Hornblower was actually an English occupational name for the foreman of a crew of workers who blew

a horn to start and end the workday. Furthermore, there is a logical compression of someone using a hornpipe to blow smoke rings that might suggest a name like Hornblower for the inventor of pipe smoking.

TOBACCO AND TEA
HOBBITS AND BROWNIES

One very curious thing about Hobbits is that the care Tolkien takes in making them the sprites of Old England (in the sense of being authentically Anglo-Saxon) is often thrown away with anachronisms that are characteristic of Victorian or Edwardian England. Nothing could be more typically nineteenth- and twentieth-century English than tobacco and tea—and nothing could be less Old English. One is from America and the other from India; regions totally unknown to Anglo-Saxons, but both familiar parts of the Victorians' world.

Tolkien's Hobbit culture is a distillation of all that is fundamentally English regardless of era. The anachronisms are intentional and meant to be humorous, but at the same time they show how Hobbits are *spiritus mundi* of the tamed landscape of England, not the wild original lands of Britain. That is why Tolkien's Hobbits are derived from the English Hobs and Hobmen, but are linguistically distinct from those older British sprites, the Brownies.

In many obvious ways Hobbits are modelled on these ancient hill people of Britain. Brownies are diminutive, earth-dwelling, elusive, and usually helpful creatures. However, Brownies are essentially Celtic in spirit, while the Hobbits are absolutely English.

What Tolkien has given us in his tea-swilling, pipe-smoking, middle-class Hobbits is a distinctively English translation of the rather wild and anything-but-middle-class Brownies of the Celts.

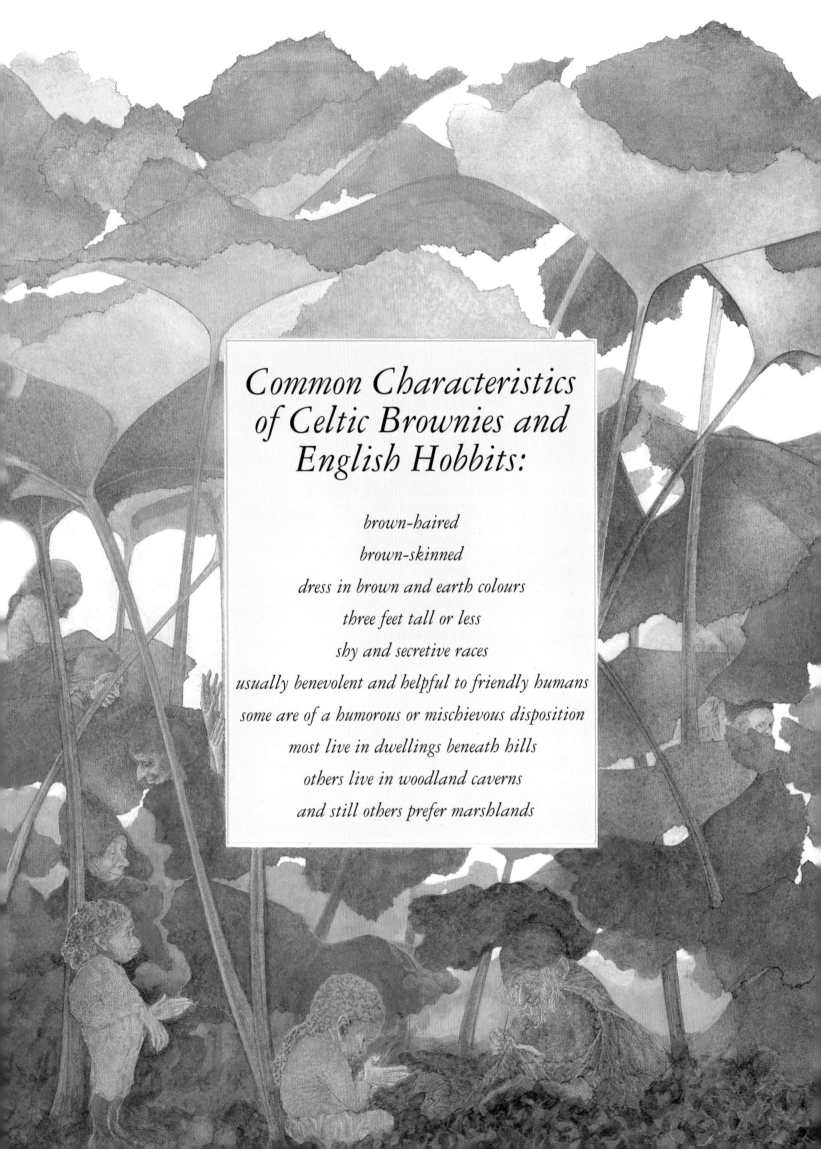

Common Characteristics of Celtic Brownies and English Hobbits:

brown-haired

brown-skinned

dress in brown and earth colours

three feet tall or less

shy and secretive races

usually benevolent and helpful to friendly humans

some are of a humorous or mischievous disposition

most live in dwellings beneath hills

others live in woodland caverns

and still others prefer marshlands

FROM BUCCA THE HOBBIT TO PUCK OF POOK'S HILL

One story which undoubtedly influenced Tolkien's writing was Rudyard Kipling's *Puck of Pook's Hill*. This is the story of Shakespeare's Puck as one of the last survivors of the People of the Hills, little brown, blue-eyed, freckled folk measuring just two to three feet, who live in secret dwellings beneath the ancient "hollow hills."

In Kipling's tale we learn that Puck's people were once powerful pagan gods who came to Britain with the first oak, ash, and thorn trees. But now that all the great forests are gone, only a few survive to hide away in the hills and hollows of England.

Beyond the fact that Puck's people strongly resemble Hobbits, there are elements of Elrond Half-Elven, Tom Bombadil, and Treebeard the Ent in Puck's laments on the lost glories of the ancient world. But if we wish to see a true parallel between Puck's people and Tolkien's Hobbits, we need only look at the evolution of the name Puck.

From Shakespeare to Kipling, the name Puck has become the traditional name for a mischievous—but not malicious—English sprite or hobgoblin.

Where did this name come from?

PUCK *is a Medieval English hobgoblin.*
PUCKEL *or* PUKA, *an Old English hobgoblin*
PUCCA *or* POOKA, *an Ancient Irish hobgoblin*
BUCCA *or* BWCI, *an Ancient Cornish or Welsh hobgoblin*

What we witness here is the translation of the original Celtic hobgoblin, Bucca, into an English hobgoblin, Puck. However, it is no accident that one of the founding fathers of the Hobbits was called Bucca. It is another example of obscure Hobbitish humour: Tolkien implies that in the Hobbit Bucca we have the original archetypal British sprite, while Puck is but a pale imitation, only vaguely understood by Shakespeare and others.

Similarly, but with deeper understanding, by connecting Bucca to Puck, Tolkien declares his intention to draw up a comparable translation process in his transformation of Celtic Brownies to English Hobbits.

Holman Greenhand, ancestral first gardener of Hobbiton-on-the-Hill

X. *The Shire &* MICHEL DELVING

THE SHIRE *is the Hobbit homeland: a green and pleasant land of orderly farms and hill villages. It is well watered by rivers and streams, and provided with lush meadows, hedgerows, and ample woodlands. The Shire is the heartland of Middle-earth, and Britain's Shires are the heartland of England.*

The word *shire* comes from the Old English *scir,* which was the name of the main unit of Anglo-Saxon government (later known as counties) in England before the Norman Conquest and was under the control of a sheriff.

Originally, the sheriff was the Shire-reeve (*scir-gerefa*), who was the monarch's representative and chief official for local administration. After the thirteenth century, his power decreased with the introduction of county courts and local officials, and although the sheriff was still the chief officer of the Crown, his role became largely ceremonial.

Organizationally, the Shire was also very like the Shires of England with its mayors, musters, moots, and sheriffs. It shared folk traditions similar to British spring, mid-summer, and autumn fêtes, fairs, and festivals. It also shared the inhabitants' loyalty to the monarchy, distrust of all outside influences, and unquestioning acceptance of tradition that amounted to an almost pig-headed conservativeness.

The character of the Shire is very like that of the Shires of England. In fact, Tolkien acknowledged that his Shire was largely modelled on the Midlands (and Oxfordshire, in particular) around the turn of the century in the last years of Queen Victoria's reign. In many ways it was an idealized (and yet gently satiric) view of England the Good at the zenith of its power.

ORDERING OF THE SHIRE

The Shire's actual shape and structure appear to have been governed by Hobbits, or rather the root word: Hob. The first of our Dictionary Hocus-Pocus words, Hob is the word with the most homonyms in the entire list. In this case, the definition "axis or centre of a wheel from which spokes radiate outward" geographically describes the shape of the Shire as the Hobbit homeland, both its external borders and its internal divisions.

HOB: *Axis or hub of a wheel from which spokes radiate outward*

The Shire is shaped like a child's wobbly drawing of the large front wheel of an old-fashioned Penny-farthing bicycle, and has a diameter measurement roughly equal to forty or fifty leagues: 120 to 150 miles. The four great spokes of the wheel radiate out from the hob, and divide the Shire into four regions known as the Four Farthings. This is logical enough as farthing comes from the Old English *feorthing,* meaning fourth or a fourth part. The central hob of the Shire is marked geographically with a large standing stone, known as the Farthingstone.

To the Four Farthings of the Shire there were later appended the lands known as the Eastmarch and the Westmarch: the regions of Buckland and the Tower Hills.

The Shire is full of names found in the English landscape today that derive from the same peculiar sources. A name such as Nobottle, both in the English Shires and in the Hobbit Shires, sounds to the contemporary ear like a joke about meek Hobbitish inhabitants who "lost their bottle" or courage. In fact it is an Old English compound of *niowe,* or new, plus *botl,* or house, which can also be translated as Newhouse, or Newton, or Newbury. Indeed, there was one very real Nobottle in Northamptonshire not far from Farthingstone, just

White Cliffs of Michel Delving

thirty-five miles from Tolkien's Oxford home. Meanwhile, just twenty-five miles south of Oxford was Newbury (another variation on Nobottle) in Berkshire and not far from Buckland.

Similar etymological histories can be found to explain why the Hobbit Shire and the English Shires share many geographic names: Dunharrow, Gladden, Silverlode, Limlight, Withywindle, Cherwell, Bree, Combe, Archet, Chetwood, Bucklebury, Budgeford, Hardbottle, Oatbarton, Stock, Frogmorton, Sackville, and scores of others.

SHIRE CAPITAL: WHITE CLIFFS OF MICHEL DELVING

The capital city of the Shire is Michel Delving on the White Downs. The name Michel Delving is perhaps something of a Hobbit ish joke in imitation of one of Dickens's novels. One might suggest that humans have "Great Expectations," while less ambitious Hobbits are content with "Great Excavations". (*Michel* is Old English for great, and *delving* for excavation.)

Michel Delving was built on the imposing high ridge of the White Downs, ideal terrain for the construction of its substantial Smials. It is also the official residence of the sheriff or mayor of the Shire, and therefore boasts the Shire's largest great hall, which is known (with typical Hobbit humour) as the Town Hole. Here are to be found whatever civil and social services are on offer to Shire Hobbits.

Michel Delving is also a substantial commercial centre and the venue for many holiday fêtes and fairs every year. These events are presided over by the mayor, who is also the sheriff and the postmaster general. The city is consequently the location of a considerable number of other civic offices: the post office, the messenger service, the Shire police called The Watch, and the Mathom House, or Shire Museum.

One notable mayor of Michel Delving during the time of the War of the Ring was Will Whitfoot, who was exceptionally fat, even for a Hobbit. However, most mayors in Tolkien's books are fat—in part, one suspects, because Tolkien knew that the word mayor actually means larger (from the Latin *major,* meaning greater or larger). Consequently Will was the fattest Hobbit in the Shire. His name Whitfoot (Old English, literally meaning White-foot) was logical enough, because the town of Michel Delving was cut into the white cliffs of the chalk downs.

Without any doubt, Whitfoot was a common Hobbitish name for the region. However, the name was probably what inspired Tolkien to invent the comic tale of the partial collapse of the great hall of the Town Hole. In the middle of a meeting the roof caved in, causing a huge plume of white dust to rise above the village. Fortunately, no one was hurt, but the mayor of the day, Will Whitfoot, emerged covered in chalk dust. It was widely reported that the rotund Will looked like a huge uncooked flour dumpling, and Mayor Whitfoot of Michel Delving was known ever after by the nickname Old Flourdumpling.

XI. *Hometown of* HOBBITON

Although Michel Delving is the capital of the Shire, and there are many larger and more imposing towns, the most famous Hobbit village is Hobbiton-on-the-Hill. Hobbiton is a modestly typical Hobbit settlement. It is not famous because of its size or location. Hobbiton's only claim to fame is that it is the home of the Baggins family of Bag End on Hobbiton Hill.

The name Hobbiton simply means Hobbit town. But looking at the many homonyms of Hob such as hub, axis, nave, and centre, we could interpret Hobbiton as the Hub Town of the Hobbits. Looking this time at other Hob homonyms—hub, hump, hill—we could also interpret it as Hill Town of Hobbits.

In the English Shires are scores of hollow hills: burial mounds, barrow graves, and tumuli that are known locally as Hob Hill Houses or Hobthrush Houses. In popular mythology these Hobs are believed to be hairy little Brownies of sorts, variously named

Hobs, Hobmen, Hob-i-t'-hursts, Hob Thrushes, and Hob Thrusts. Only a few miles from Tolkien's home was Hob Hurst's House, an ancient round barrow which is not typically remembered as a tomb, but as a house or hollow hill wherein the spirit called Hob Hurst still lives beneath the mound.

Hobbits are both hole-dwellers and hill-dwellers. How did this come about? Perhaps the reason is in part buried deep in the roots of the language: is there a connection between hill and hole?

HOLE—*Modern English* HOLLOW (hole)—*Old English* HOHL (hole)—*German* KUD (hole)—*Gothic*

HILL—*Modern English* HILL (hill)—*Gothic* KHULNIZ (hill)—*German* KHULNIS (hill)—*Latin* KULNIS (hill)—*Prehistoric German*

HOBBITON → *Hobbit Town* → *Hub Town of Hobbits* → *Hill Town of Hobbits* →

FROM HOLE TO HILL

KHULAZ (hollow)~*Prehistoric German* ➤ Originates in→KOL (cover)~*Indo-European root word* ➤ COLLIS

Hobbiton-on-the-Hill

XII. BAG END:
The Hobbit Home

If one wishes to study the design and view the interior of an ideal Hobbit smial, one could do no better than examine the home of the famous Bilbo and Frodo Baggins at Bag End. Considered the finest Hobbit hole in the ancient village of Hobbiton, it is a rather magnificent, but perfectly traditional, Hobbit smial.

The epitome of the country gentlehobbit's home, it is well designed, warm, cosy, and extremely comfortable, but without any grand pretensions. The no-nonsense nature of this family smial is emphasized by its name: Bag End.

There is an element of social satire here because Bag End is another of Tolkien's Hobbitish linguistic jokes. Bag End is a literal translation of *cul de sac*: a phrase that belongs to no language. It was a term invented in the early twentieth century by snobbish estate agents who felt the term *dead end* was too common. The Frenchified *cul de sac* was considered more cultured, even though it is a nonsensical term to the French, who actually call such a road an *impasse*.

BAG END
→ CUL DE SAC *in fractured "Franglais"*
→ IMPASSE *in French*
→ DEAD END *in English*

Tolkien's Baggins family of Bag End are authentically Hobbitish and would have no truck with this kind of Frenchified silliness. However, this is exactly why the obnoxious, social-climbing side of the Baggins family took on the double-barrelled name of Sackville-Baggins. The fact that they came from Sackville in Southfarthing and insist on using this Frenchified double-name tell us everything we need to know about this branch of the family. Absurdly, the pretentious Sackville-Baggins accurately rendered would have been the ridiculous and down-market name of Bagtown-Baggins.

SACKVILLE → *literally translates as Bagtown*
SACKVILLE-BAGGINS → *literally translates as "Bagtown-Baggins"**

All in all, Tolkien's perspective on Bag End is a gentle satire of English middle-class "home and garden" society. As a rule, Tolkien despised the pretension and snobbery that looked down condescendingly on all things English. He preferred plain English in language, in food, in culture. The Hobbit home of Bilbo Baggins at Bag End is the epitome of everything that is honestly and plainly English.

Through the Hobbits at Bag End, Tolkien extols the Englishman's love of simple home comforts. They are seen as both ideal and absurd: a view that is part delight, part mockery. All in all, it only seems surprising that he didn't write a parody aphorism along the lines of, "the Hobbit's hole is his castle."

DESIGN OF THE BAG END SMIAL

All Hobbit holes or smials follow a single fundamental plan. Although Bag End is more extensive than most, it does not depart from the basic design tenets of a typical smial. A central tunnel or smial is dug into a hillside. On either side of this corridor, rooms are excavated.

The central tunnel is usually dug parallel to the slope of the hill, entering it at one point and emerging via a back door at the other end. Rooms excavated on one side of the corridor will have round windows with garden views; rooms on the other side, naturally enough, will have none.

* Closer than the Sackvilles would want to "Bag-End-Baggins"

There are no stairs in Hobbit homes: the rooms are all on one level, and they are similar to the homes of Human country squires—although there is a rather heavier emphasis on large pantries, kitchens, and cellars for food and drink; and on wardrobes, chests, drawers, and closets for clothes.

Hobbits are fine and skilful craftsmen, so their homes are well made, from the polished brass knob on the round porthole front door to the polished brass knob in the round porthole back door. The tubelike central corridor and all the rooms are finely crafted with wood-panelled walls and beautifully tiled and carpeted floors. The rooms are all cosy and well ventilated, well lit and heated with substantial fireplaces. They are filled with exquisite handmade furniture, all of which is neatly polished, painted, and fully upholstered for maximum comfort.

HERITAGE OF BAG END—THE HOUSE THAT BUNGO BUILT

Bag End was built by Bilbo Baggins's father, Bungo Baggins. Oddly enough, this simple revelation leaves the reader open to a barrage of Tolkien's dreadful Hobbitish puns pivoting on the word *Bungo*. Bag End was Bungo's house; however, in original Hobbitish (in which masculine names end in *a*) his name was Bunga. Therefore Bag End was Bunga's House, which was a *bungalow*, or a "low one-storey house," which is a fairly accurate description of a Hobbit smial like Bag End.

<div align="center">

BAG END

→ *Bunga's House* → *Bungalow* → *Low One-Storey House*
→ *Bunga's Smial* → *Bag End*

</div>

Furthermore, Bungo's House is also Bungo's Hole, and the common English term *bunghole*, as a place into which things are carelessly thrown, comes from the term *bung*, meaning "to shut up with a cork or stopper." This is evocative of the Hobbitish habit of filling their holes up with clutter, bunging things in and never throwing them away. Also, the bung hole in the end of a wine or beer barrel suggests the round door at the entrance of the Hobbit house.

<div align="center">

BAG END

→ *Bungo's Hole* → *Bunghole*

</div>

Nor does it quite end there. From the sixteenth century to the early twentieth century the English slang term *bung* had a similar meaning to the word Bagg in Baggins; that is, a "purse or pocket." Therefore, Mr. Bungo Baggins of Bag End could almost be reduced to a simplistic Mr. Bag Bag of Bag End.

<div align="center">

BUNGO BAGGINS

Bung(o) → *Bung* → *Purse* → *Money Bag* → *Bagg* → *Bagg(ins)*

</div>

By the nineteenth century Bung had become a verb: to *bung* meant to throw away. From this came the slang *bungo*, which meant "to disappear," especially in connection with money: literally *bung-go*, meaning "purse-gone."

<div align="center">

BUNGO

→ *Bung-Go* → *Disappear* → *Purse-Gone* → *Bag-Gone* → *Baggins-Gone*

</div>

It appears that Bilbo Baggins inherited not only Bag End bungalow from his father Bungo, but also the Baggins's tendency to bungo (disappear). Bungo (and his wife) both went bungo after a boating accident, never to return. Bilbo Baggins went bungo twice: once after his "Unexpected Party" at the beginning of *The Hobbit*, and again after his "Long Expected Party" at the beginning of *The Lord of the Rings*. *

* Frodo Baggins carried on the disappearing tradition by going bungo at the beginning and the end of *The Lord of the Rings*.

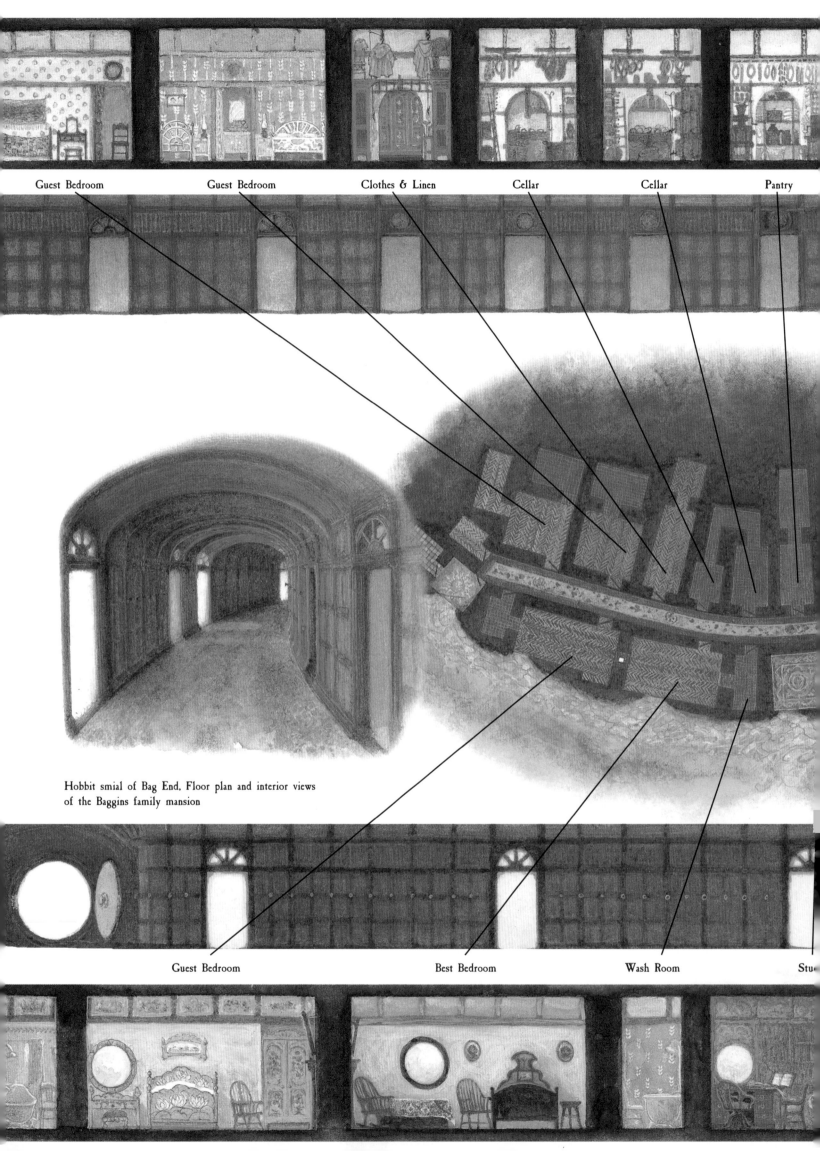

Guest Bedroom Guest Bedroom Clothes & Linen Cellar Cellar Pantry

Hobbit smial of Bag End. Floor plan and interior views
of the Baggins family mansion

Guest Bedroom Best Bedroom Wash Room Stu

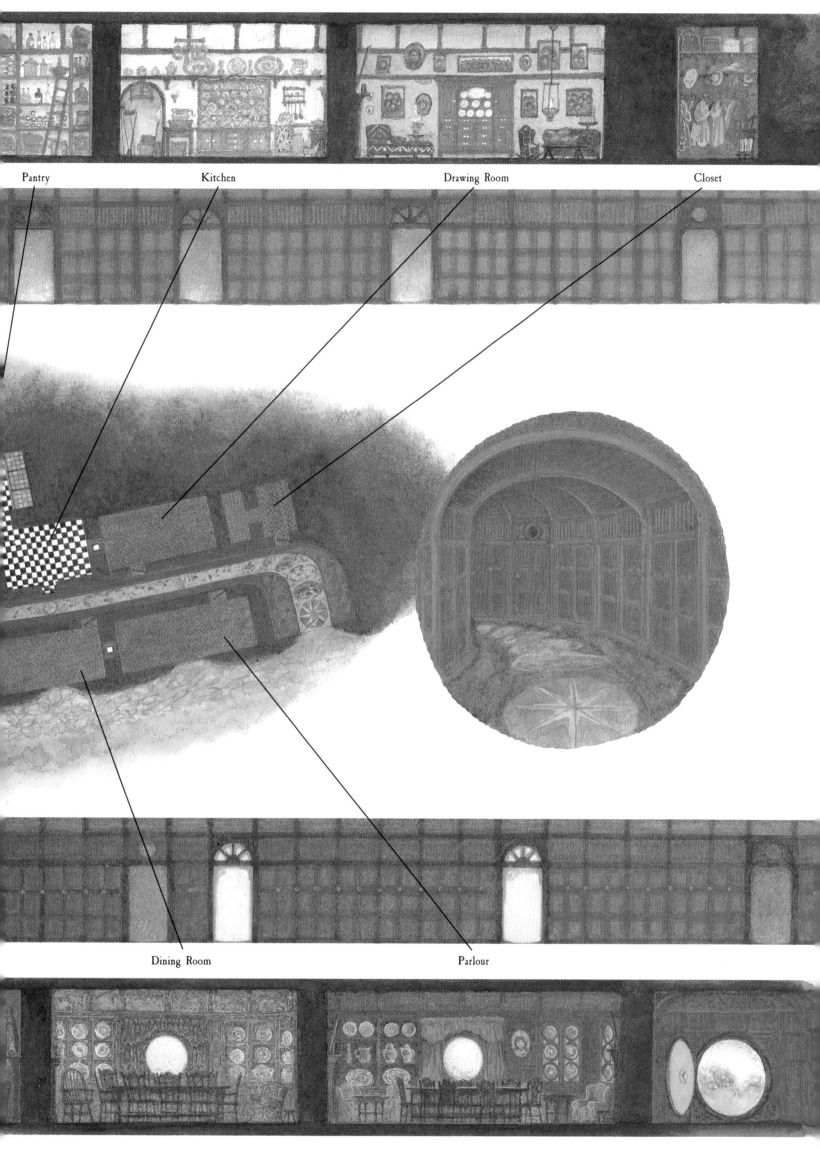

Pantry

Kitchen

Drawing Room

Closet

Dining Room

Parlour

XIII. *A Conspiracy of* DWARVES

The quiet life of Bilbo Baggins of Bag End is forever disturbed by the unexpected arrival of thirteen conspiring Dwarves. Known as Thorin and Company, these conspirators recruit the respectable Hobbit as a specialist burglar and entice him off on their adventure.

Who and what are these Dwarfs or Dwarves? And how and why did they become involved in this adventure or quest?

First of all they are Dwarves, not Dwarfs. Tolkien wanted specifically to address the issue of the Dwarfs as a race of bearded, stunted people, rather than Humans of a vertically challenged stature. He began his attempt to define and standardize the race by recognizing a proper plural term for these people. Tolkien came up with *Dwarves*, although he acknowledged that in proper linguistic terms it would be more correct to call them *Dwarrows*.

DWARF *(Modern English)~plural is Dwarfs*
DWEORH *(Old English)~plural is Dwarrows*
DWEORH *(Westron)~plural is Dwarrows*
DWARF *(translated Westron)~plural is Dwarves*

So you find in Tolkien's books *Dwarf* (Modern English) becomes Dwarfs in plural; *Dweorh* (Old English and Westron, the common speech of the Westlands of Middle-earth) becomes Dwarrows; and *Dwarf* (translated Westron) becomes Dwarves. Furthermore, the origin of Dwarf is in the Indo-European root word *dhwergwhos,* meaning something tiny.

DWARF is derived from:
DWEORH *(Old English)*
DVERGR *(Old Norse)*
TWERG *(Old High German)*
DVAIRGS *(Gothic)*
DWERGAZ *(Prehistoric German)*
DHWERGWHOS *(Indo-European)*
meaning "something tiny"

In *The Hobbit*, the Dwarves making up Thorin and Company are largely of the comic fairy-tale variety. These Dwarves would not be out of character if found in *Snow White and the Seven Dwarfs* or *Rumpelstiltskin*. Here we find all the vague associations with hoarding gold, digging mines, and the Dwarf's sullen and stubborn character.

However, by the time of *The Lord of the Rings,* Dwarves have become a species unique to Tolkien's epic world of Middle-earth. In their own language they are the *Khazad*. They are a rather dark and brooding race with the fatalistic, foredoomed nature of the Dwarf Smiths of Viking mythology.

The names of the individual Dwarves are not, of course, drawn from our Hocus-Pocus Dictionary List, but another list altogether. Tolkien took the names directly from the primary source of Viking mythology: the text of Iceland's twelfth-century prose *Edda*. The *Edda* suggests a crude account of the creation of the Dwarfs, then lists their names; this list is usually called the *Dvergatal,* or the Dwarfs' Roll.

All the Dwarves in *The Hobbit* appear in this list: Thorin, Dwalin, Balin, Kili, Fili, Bifur, Bofur, Bombur, Dori, Nori, Ori, Oin, and Gloin. Other names of Dwarfs which Tolkien found in the *Edda* and used later include: Thrain, Thror, Dain, and Nain. The *Edda* also gives the name Durin to a mysterious creator of the Dwarfs. Tolkien uses this Icelandic name when he creates the first Dwarf of Durin's Line.

Tolkien took the *Dvergatal* and speculated on why it was created. Essentially, he saw the list of Dwarfs as one of his Hobbitish riddles.

The answer was that it was a riddle about a lost epic of the Dwarfs; or perhaps an epic about the

Langobards (meaning Longbeards, an alternative name for Tolkien's Dwarves), a long-lost Germanic tribe who, legend tells us, lost their treasure and kingdom to Dragons.

RIDDLE: *"What was the* Dvergatal*?"*
ANSWER: *"The lost epic of the Dwarfs."*

To discover something of that lost epic tale that the Dwarves once recited "in their halls of stone," Tolkien used such clues as he could find.

Once again he delved into the language to answer his questions. Primarily he used the list of Dwarfs' names to recreate the Quest of the Dwarfs.

Not surprisingly, the name of the leader of the Dwarf Company of Adventurers is Thorin, whose name means Bold. However, Tolkien also gave him another Dwarf-name from the list: Eikinskjaldi, meaning "he of the Oakenshield." This name was responsible for a complex piece of background history wherein, during a battle in the Goblin Wars, Thorin broke his sword but fought on by picking up an oak bough that he used as both a club and a shield.

Thrain, meaning Stubborn, was the name of Thorin's father, who was slain by Dragons when he stubbornly resisted the Dragon's invasion of his realm. Thorin's sister was Dis, which simply means sister. Thorin's heir and avenger, who led the Dwarves of Iron Mountain, Dain Ironfoot, meaning Deadly Ironfoot, proved to be true to his warrior name.

The names of other members of the Company were instrumental in shaping them. Bombur, meaning Bulging, was certainly the fattest of the Dwarves, and Nori, meaning Peewee, was the smallest; Balin, meaning Burning One, was fiery in battle, but warm with his friends; Ori, meaning Furious, fought furiously before he was slain in Moria; and Gloin, meaning Glowing One, won glory and riches.

As we have seen, the name Durin was also given to a mysterious creator of the Dwarfs and Tolkien used it as the name of the First King of the Dwarves. If taking a comic turn, one could translate Durin as Sleepy, the name of one of Snow White's Seven Dwarfs (which was taken from the same source). However, Tolkien

creates an epic character in Durin, the greatest of the Seven Fathers of the Dwarves and the first of the Seven Sleepers to awake in the "Halls of Stone" and bring the race of Dwarves into the world.

There seems little doubt that the *Dvergatal* list of names was a primary motivator for Tolkien and the means by which he "discovered" the history, origin, and character of his Dwarves. In large part, the grand adventure of *The Hobbit* was Tolkien's explanation for the gathering of the Dwarves and his eloquent answer to the mysterious Riddle of the *Dvergatal*.

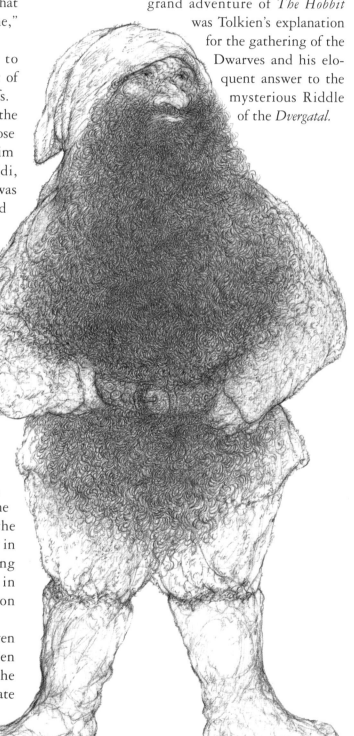

XIV. *Conjuring* GANDALF *the* WIZARD

Just as the Dwarves of Thorin and Company begin their adventure in The Hobbit *as standard creatures of the fairy-tale variety, Gandalf the Wizard also appears as a rather comic eccentric fairy-tale magician. In* The Hobbit, *Gandalf has something of the character of the absent-minded professor and muddled conjurer about him.*

It is Gandalf who brings the Dwarves and the Hobbit together and begins the quest. It is his injection of adventure and magic into the mundane world of the Hobbits that transforms Bilbo Baggins's world. It is Gandalf who leads the band of outlaw adventurers in the form of Thorin and Company to Bilbo's door. And it is just this combination of the everyday and the epic that makes *The Hobbit* so compelling. Grand adventures with Dragons, Trolls, Elves, and treasure combine with the everyday pleasures of afternoon teas, toasted muffins, pints of ale, and smoke-ring-blowing contests.

So, in *The Hobbit*, Gandalf is a fairy-tale magician with the traditional pointy hat, long cape, and wizard's staff. He is an amusing and reassuring presence—like a fairy godfather. His later transformation in *The Lord of the Rings* is something of a surprise, but then Tolkien is making the point that behind all fairy-tale magicians there are powerful archetypes from the myths and epics of a racial past.

The sources of Gandalf are many.

GANDALF
>> *Merlin of the Celts*
>> *Odin of the Norsemen*
>> *Woden of the Early Germans*
>> *Mercury of the Romans*
>> *Hermes of the Greeks*
>> *Thoth of the Egyptians*

All are linked with magic, sorcery, arcane knowledge, and secret doctrine. Gandalf, Merlin,

Odin, and Woden were identical figures who usually took the form of a wandering old man in a grey cloak who carried a staff. Gandalf was comparable to the others as well in powers and deeds. Typically these wizards served as a guide to the heroes and frequently helped them advance against impossible odds by using their supernatural powers.

In the first drafts of *The Hobbit*, J. R. R. Tolkien had not chosen Thorin Oakenshield as the leader of the Dwarves. Surprisingly, the original name of the leader was Gandalf; a Dwarf-name that also appears in the *Dvergatal*.

It was not until later drafts that Gandalf the Dwarf was transformed into Gandalf the Wizard. Undoubtedly, the literal meaning of Gandalf—which has usually been translated as "sorcerer elf"—had something to do with inspiring Tolkien to dispose of an extraneous Dwarf, and introduce an absolutely essential Wizard.

However, looking more carefully at the elements of Gandalf's name, it is obvious that there are several ways of translating it. Its meaning shifts just about as much as the wizard's identity. Indeed, it is easy to see how the name Gandalf itself might have been used as the inspiration for the twist in the plot of *The Lord of the Rings,* wherein Gandalf the Grey is transformed into Gandalf the White.

Gandalf comes from a name in the Icelandic *Dvergatal*: Gandalfr. The Old Norse element of Gandalfr, when translated, is GAND—meaning a magical power or the power of Gand, that is, "astral travelling."

Alternatively, the elements may be GANDR—an object used by sorcerers or the enchanted staff or

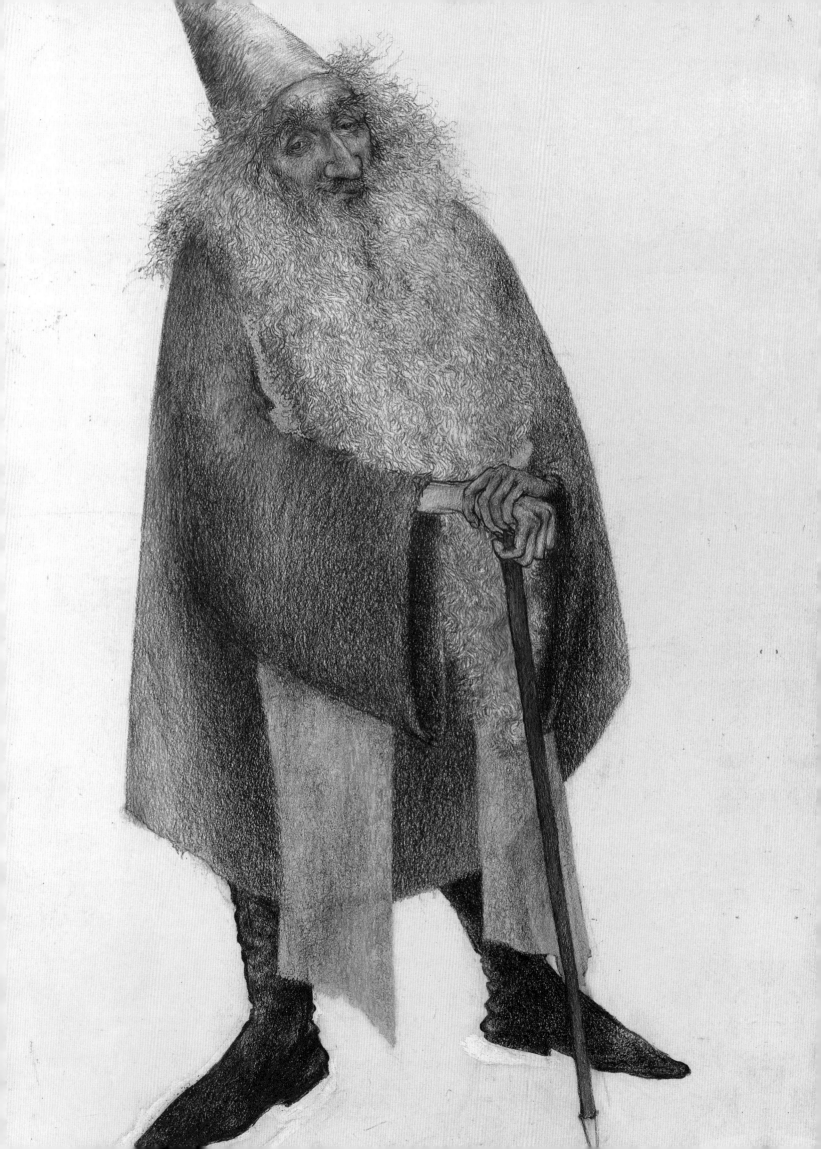

the enchanted crystal of a wizard; and ALF—elf or white.

Therefore the three best translations of Gandalf's name are ELF SORCERER, WHITE STAFF, and WHITE SORCERER.

All three translations are admirably suitable for a wizard's name. (Wizard itself simply means wise man.) However, each has a hidden meaning within it, which influenced the fate of the character.

GANDALF~*Elf Sorcerer*

The translation Elf Sorcerer or Elf Wizard applies descriptively, because Gandalf is the Wizard who becomes most closely associated with the Grey Elves of Middle-earth. Also, although not an Elf, Gandalf was a supernatural spirit from Aman, the realm of the Light Elves. Thus the name Gandalf seems to have suggested a plot that would eventually return the Elf Sorcerer to his Elvenhome across the Western Sea.

GANDALF~*White Staff*

When Gandalf first appears in *The Hobbit*, he is described as an old man with a staff. The staff is the primary symbol by which a wizard is known, for it is the ancient sceptre of power in disguise (*sceptre* being the Greek word for staff). The staff is also the vehicle by which all wizards wield power. The fact that the staff is white suggests a wizard who commands white or good sorcery rather than black or evil sorcery.

GANDALF~*White Sorcerer*

The translation White Sorcerer or White Wizard is probably the best and simplest translation of Gandalf. Initially disguised as Gandalf the Grey, a rather ragged old conjurer, throughout his many adventures he uses only white or good sorcery. And, in the end, his true nature is revealed when he is reincarnated as Gandalf the White Wizard.

The translation of Gandalf as White Wizard demonstrates precisely how influential the meaning hidden within a name could be for Tolkien. Initially Gandalf was given the title and rank of Grey Wizard, and another individual named Saruman was the White Wizard.

We are told that Saruman the White Wizard's Elven name was Curunir, which means Man of Skill—a reasonable name for a white wizard. However, the name Saruman* is an Old English construct meaning Man of Pain, a name which could only be given to an evil (black) wizard.

Similarly, we are told that Gandalf the Grey Wizard's Elven name was Mithrandir, which means Grey Wanderer—a reasonable name for a grey wizard. However, as we have seen, the name Gandalf is an Old Norse construct meaning White Sorcerer, a name that could only be given to a good (white) wizard.

As we have come to appreciate, the hidden meaning of names often predicts the fate of Tolkien's characters: Saruman the White Wizard became the evil sorcerer of Isengard, while Gandalf the Grey Wizard was reincarnated as Gandalf the White Wizard.

Once again, Tolkien is acting the part of a magician and has set us up for a conjurer's trick with language: a little verbal "hocus-pocus" wherein white becomes black, and grey becomes white. **

* Another example of Tolkien's Old English puns: *Saromann* means Man of Pain; however the similar *Searomann* means Man of Skill.

** Not content to let even the most obscure association go unjested, Tolkien appears to have further linked his wizards' fates to a couple of alternative translations of the first element in Gandalf's name: *gandr* as an enchanted crystal and *gand* as astral travelling. For, strangely enough, we find that Saruman's downfall comes through his use of an enchanted crystal called the *palantir*, while the salvation of Gandalf comes through a form of astral travelling that permits his resurrection.

XV. TROLLS & GIANTS

The obstacles to Bilbo Baggins and Thorin and Company developed out of Tolkien's investigations into the fragments of Anglo-Saxon literature. The language itself was Tolkien's way into this world; often phrases or single words suggested whole chapters and scenarios. He also began to define clearly and standardize the elusive forms of mythic creatures inhabiting the Anglo-Saxon language.

Tolkien insisted on clarifying definitions and forms in language, such as altering Dwarfs to Dwarves and Dwarfish to Dwarvish, while Elfs became Elves and Elfin became Elven. In Old English and Norse tales there is considerable confusion between the definitions of Elfs, Dwarfs, Giants, Hobs, Ents, Fairies, etc. Tolkien wished to put an end to this. In the case of Elves in particular, Tolkien defined the Elf as a distinct and singularly important race.

In its etymological history, he also found that Elf was an extraordinarily strong and consistent word through many languages:

ELF~*English*
AELF~*Old English*
ALFR~*Old Norse*
ALP~*Old High German*
ALBS~*Gothic*

In all languages Elf means white (the Latin *alba* and Greek *alphos* both mean white), and also retains an association with Swan.

Many aspects of various beings and monsters in Tolkien's world have evolved from Old English and Germanic words. In the epic poem *Beowulf,* for instance, Tolkien's imagination was fired by one phrase that described the tortured races who were thought to be the descendants of the cursed biblical brother, Cain. In this one phrase we have three of Tolkien's invented species. The Old English wording is *eotenas ond ylfe ond orcneas,* meaning "ettens and elves and demon-corpses," or more simply "trolls and elves and goblins."

Elsewhere in Anglo-Saxon literature we have a jumble of words for a confusion of creatures that Tolkien shaped and standardized:

ORCNEAS~*demon-corpses or goblin zombies in Old English*

ORCPYRS~*demon-giants or goblin giants in Old English*

WARGS~Vargr *(wolf) in Old Norse +* Wearh *(human outlaw) in Old English, suggestive of "skin-changers" or werewolves*

BERSERKERS~Bear + Sark *(bear-shirt warrior cult) in Old Norse, suggestive of "skin-changers" or werebears*

EOTEN~*giant or ent in Old English*

JOTUNN~*giant in Old Norse*

TROLL~*giant or monster from Norse*

BILBO BAGGINS THE BUNGLING BURGLAR

At the beginning of *The Hobbit,* Bilbo Baggins appears to be totally incompetent as a mercenary burglar. Why would Gandalf the Wizard insist on the Dwarves hiring such an absurd creature for this job? Indeed, Bilbo Baggins is only shamed into attempting the role as master burglar or thief. Unfortunately, he is caught first time out trying to steal from three Trolls of the Trollshaws (literally troll-woods).

Although immensely stupid by Human and Hobbit standards, these monsters—Bert, Tom, and William Huggins (rhymes with Muggins, meaning fool, idiot)—were capable of speech. This made them geniuses among Trolls, and smart enough almost to end Bilbo Baggins's career before it began.

The episode with the Trolls is rather imitative of the Grimms' tale *The Brave Little Tailor*, and other trickster tales from Icelandic mythology. However, it is the Wizard Gandalf who uses his wits to keep the Trolls arguing until the sun rises and turns these creatures of darkness to stone.

The point of the story of *The Hobbit* is that it traces the initiation and education of the Hobbit from everyday person into epic hero. In this, Gandalf the Wizard is the Hobbit's mentor.

The episode with the Trolls is Bilbo Baggins's first lesson in using his wits to outsmart the large and powerful. After passing this first test he wins a prize from the Trolls' treasure hoard: a magical Elven dagger with the name Sting. Aside from being an extremely effective weapon with an ancient heritage, Sting is Bilbo's bilbo: it is emblematic of his new-found power of a sharpened wit, and also emblematic of his true self or spirit, which is bright and more than a little dangerous.

BILBO BAGGINS THE HOBBLER

The key to Bilbo Baggins's education and the model for the kind of heroic master burglar he becomes can be conjured up from one of our Hocus-Pocus Dictionary words: *Hobbler.*

Hobbler is a nineteenth- and early twentieth-century underworld term for a specialized type of criminal who, through a combination of confidence tricks (or stings) and burglary, acquires a great deal of loot. He is an example of "dishonour among thieves," for his victim is usually another criminal who acquired his booty by theft in the first place.

The term hobbler comes from *hobble,* in the sense of "to perplex or impede." This can be done physically, but more often is done through trickery or mental process; in Tolkien's world we often see a superior force "hobbled" by trickery in the form of perplexing riddles or legally binding wordplay that almost amount to legal contracts, whether dealing with Dwarves, Orcs, Gollum, Elves, or Dragons.

Gandalf the Wizard had decided that, despite appearances, Bilbo Baggins the Hobbit was the perfect candidate for a hobbler. Being a Hobbit, there is little opportunity for Bilbo to intimidate physically, so he is more likely to learn how to "perplex, impede, and confuse" his foes, rather than confront them. If he is to survive, he must quickly learn to use his wits and a few tools of his profession to relieve other criminals of ill-gotten loot.

Bilbo Baggins's technique is perfectly described in criminal-world slang that was first recorded in Britain in 1812 (and has been used ever since): to *hobble a plant*—"to find booty that has been concealed by another; to spring the loot by deception or theft."

The phrase means roughly "the finder hobbles the planter." This is the technique employed in each major encounter; whether the planter is a Troll or Goblin, or Ghoul, or Dragon. In each case, after tricking and evading the creature, the hero-burglar gets "to spring the loot."

Under the tutorship of Gandalf, the ineffectual Hobbit seems rapidly to learn how to become a first-class hobbler. His reward for surviving the first test is his sword Sting. His reward for surviving the much more demanding test of the cannibal ghoul Gollum is the One Ring that allows him to be invisible. With these two tools of his trade, and a wit sharpened by desperation and necessity, Bilbo Baggins becomes a master thief without comparison: a Hobbit hobbler.

Bilbo's apprenticeship to Gandalf the Wizard is over with the hobbling of Gollum and the theft of his One Ring: "Thief! Thief! Thief! Baggins! We hates it, we hates it forever!" High praise indeed from a monster colleague who has been stealing and murdering for centuries.

When Bilbo Baggins rejoins the Company of Dwarves, he becomes a master thief beyond compare and the real hero of the expedition. His transformation is remarkable. In the forests of Mirkwood, Bilbo turns into a ferocious hero of the most aggressive kind who ruthlessly slaughters the evil giant spiders with his Ring and his Sting. From the trials of the spider webs and Elven prisons of Mirkwood, it is a short journey to the abandoned Dwarf-Kingdom-under-the-Mountain at Erebor, where the ultimate test of Bilbo Baggins's skills as a Hobbit hobbler lies waiting: the Dragon of Lonely Mountain.

THE QUEST FOR THE TREASURE OF

Wizard Gandalf the Grey and led by the rightful heir to the Dwarf Kingdom-under-the-Mountain,

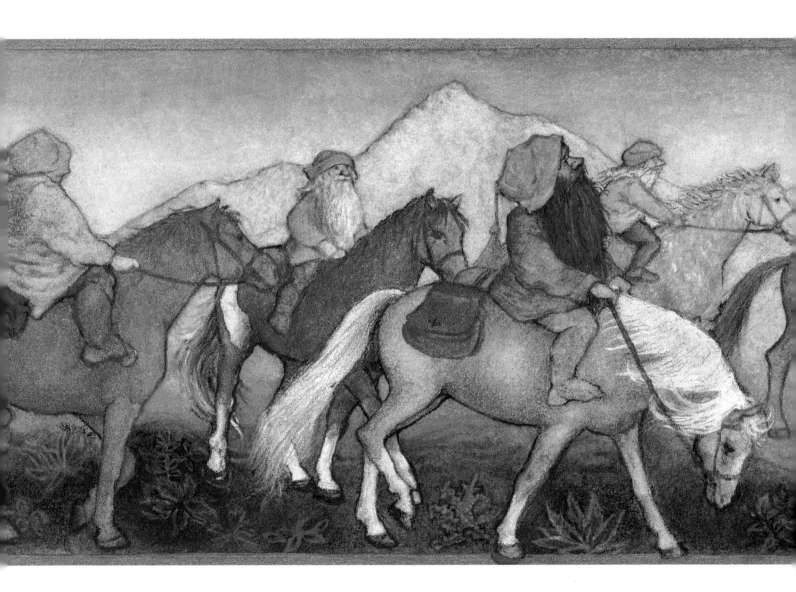

The Company of Adventurers: GANDALF THE WIZARD, BILBO BAGGINS THE HOBBIT, THORIN OAKENSHIELD,

The Quest to steal the lost treasure of Lonely Mountain from the Dragon of Erebor was guided by the

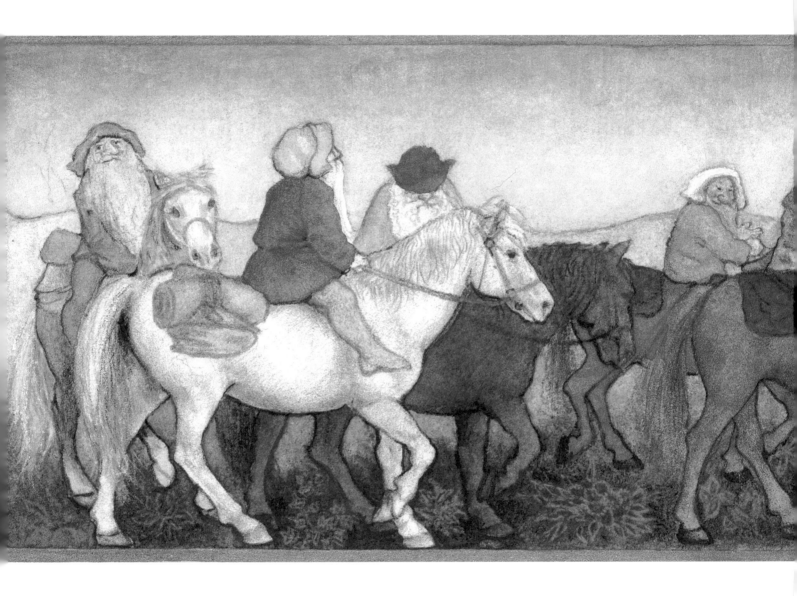

and assisted by one Hobbit of the Shire who went by the name Bilbo Baggins of Bag End.

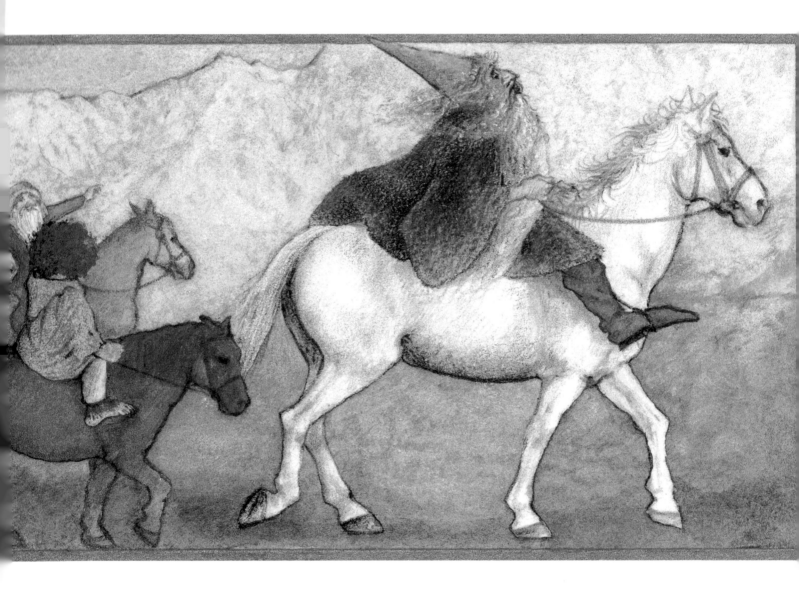

the Lonely Mountain of Erebor

Thorin Oakenshield. The Wizard and the Dwarf King were accompanied by twelve quarrelsome Dwarves,

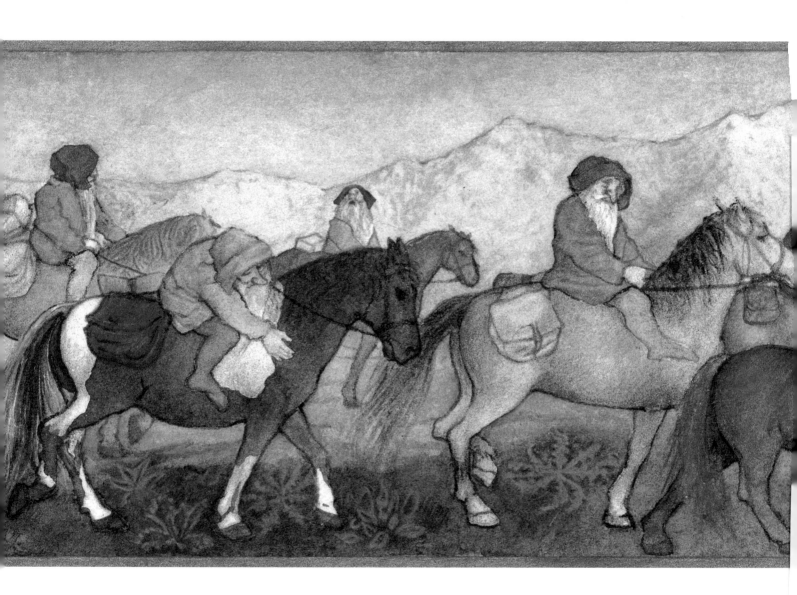

DWALIN, BALIN, KILI, FILI, BIFUR, BOFUR, BOMBUR, DORI, NORI, ORI, OIN, AND GLOIN.

XVI. *Naming the* DRAGON

BILBO BAGGINS'S ultimate test in his quest is his confrontation with that most feared of monsters: the fire-breathing Dragon. Let us examine the Dragon as a species. Let us look first at the word: DRAGON.

DRAGON~*English*

DRAGON~*Old French*

DRAKE~*Old English*

DRAKE~*Old German*

DRACO~*Latin*

DRAKON~*Greek*

DARC~*Sanskrit*

The Greek *Drakon* means serpent, but is derived from the Greek word *Drakein,* meaning "look, glance, flash, gleam." Thus, the Greek *Drakon* suggests "to see fiercely" and the idea of a watcher or fierce guardian. Similarly, the Sanskrit *Darc* has the implication "creature that looks on you with a deadly glance."

In Greek and Sanskrit the words for this Monstrous Serpent convey the sense of a Watcher with a Deadly Glance that is also a guardian of treasure or a sacred site. It also suggests a creature with the capacity to see Prophetic Visions, and to "see" in the sense of being in possession of Ancient Arcane Knowledge.

In Ancient Greece, Dragons guarded treasures like the Golden Fleece, but more often guarded sacred wells or caves of a sacred and prophetic nature. The most famous was the Dragon at the Delphic Oracle that the sun god Apollo slew with his arrow. Thereafter, he lay deep beneath the ground, but the vapours of his breath still escaped through a crevasse and put the priestesses in a trance that allowed them to prophesy the future.

As professor of Anglo-Saxon, J. R. R. Tolkien was an authority on *Beowulf,* and has acknowledged that *"Beowulf* is among my most valued sources" for his tale of the Hobbit. The two stories are not very obviously similar; however, there are strong parallels in the plot structure of the Dragon episodes of *Beowulf* and *The Hobbit.*

Beowulf's Dragon is awakened by a thief who finds his way into the Dragon's cavern and steals a jewelled cup from the Dragon treasure hoard. This is duplicated by Bilbo Baggins's burglary when he also steals a jewelled cup from the treasure hoard. Both thieves escape unscathed; however, other

Worm~*English* Wyrm~*Old English* Ormr~*Old Norse* Wurm~*Old High German* Waurms~*Gothic* Wurmuz~*Prehistoric German* Vermis~*Latin* Wrmi~*Indo-European*

All from the Indo-European root: WER, meaning "turn, twist"

Therefore, Worm~ "A twisting, turning creature"

SNAKE *is from the Prehistoric German root:*
SNAG, *meaning crawl,*
while SERPENT *is from the Latin*
SERPERE, *meaning crawl, creep*

MONSTER = DRAGON + WORM +
SNAKE + SERPENT

RIDDLE OF THE DRAGON

In the creation of his winged, fire-breathing Dragon, Tolkien took what he considered the best from the collective Dragon mythology of western cultures. He also borrowed elements suggested by the words Dragon and Worm. He then chose a name that would conjure up the ultimate Dragon —a perfect villain, completely evil and supremely intelligent.

That character was realized in a single name: Smaug.

To the contemporary reader, there is one immediate association: Smaug is a pun on the modern word smog, meaning foul, polluted smoke and fog; this implies evil brimstone smoke and vapour exhaled by a fire-breathing Dragon.

Yet it was the conundrum of an ancient Anglo-Saxon spell—rather than an air-pollution problem— that inspired Tolkien in the creation of Smaug the Mag-nificent. It began with an Old English spell for protection against Dragons: *wid smeogan wyrme,* which translates as "against the penetrating worm."

Tolkien decided the spell was not actually a spell, but a riddle. It

heroes die and nearby Human settlements in both tales suffer terribly from the Dragon's wrath.

The Hobbit is the *Beowulf* Dragon story from the thief's point of view. However, *Beowulf's* Dragon is given no personality and is not even named. If comparisons must be made, Tolkien's Dragon is closer to the crafty and evil Dragon of the Volsung Saga.

DRAGONS AND WORMS

In Old English and Norse literature—and most European mythology—Dragon and Worm are used interchangeably to describe the same monster. However, the word Worm has a very different root-meaning related to the physical characteristics associated with snakes and serpents.

Snakes and serpents are also twisting and turning creatures, and in most modern languages of northern Europe these words became entwined with the word *Worm* and its variations: *Wurm* is the German for snake; *Worm* is the Dutch for snake; and *Orm* means snake in both Danish and swedish.

Snake and serpent, however, come from different root-meanings, which add other dimensions to our composite monster.

THE FIREWORK DRAGON

Fortunately for most Hobbits, their experience of Dragons was almost entirely limited to ancient tales of Elvish Days when it was reputed that a multitude of creeping, crawling, and flying monsters stalked Middle-earth. Many Hobbits of the Shire chose to disbelieve these legends, although they still loved to hear deliciously scary legends of Dragons and heroes told over and over again.

Knowing of the Hobbits' fascination with these fearsome beasts, when Gandalf the Wizard agreed to create one of his magnificent firework displays for a special Hobbit celebration, the climax of the evening was the appearance of a terrifying, flying, swooping Firework Dragon who would light up the night sky above the Shire. This brilliant exploding and roaring of the Dragons thrilled its Hobbit audience.

Tolkien decided the spell was not actually a spell, but a riddle. It was not the spell itself, but the answer to the riddle it posed that granted protection from the Dragon. So, to solve the riddle, Tolkien first asked: "How do you protect yourself against the penetrating worm?"

Only by discovering the secret of the Dragon's name can you defeat the Dragon. Of course, this is a variation of the old Rumpelstiltskin story—and a dozen other fairy tales. All of these tales are based on the belief that naming is essentially a magical act. It is a shamanic principle shared by all tribal cultures and is based on the observation that you cannot control what you do not know. This is often summed up in aphorisms such as "know thine enemy."

Tolkien believed that (as with all good riddles) the answer was to be found within the riddle itself: *wid smeogan wyrme.* So Tolkien asked himself why the Dragon was described as the *smeogan* or "penetrating" worm. He believed that smeogan was the clue to the secret of the Dragon's name.

Tolkien keenly observed that the adjective *smeogan* (meaning penetrating) and its verb *smeagan* (to inquire into), along with the related *smeagol* (burrowing, worming into) and its verb *smugan* (to creep through) were all derived from the reconstructed Prehistoric German verb *smugan* (to squeeze through a hole).

RIDDLE: "How do you gain protection against the Dragon?" ANSWER: "By naming the Dragon."

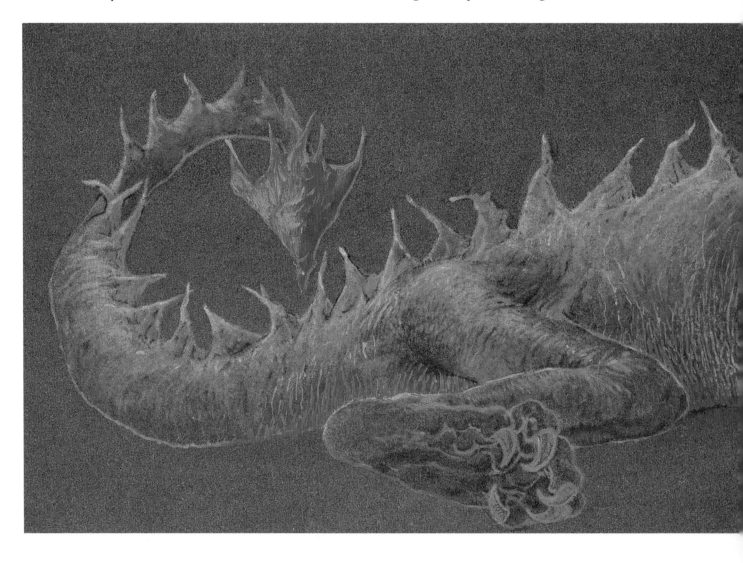

SMEOGAN~*penetrating (Old English),
from the verb*

SMEAGAN~*to inquire into (Old English)*

SMEAGOL~*burrowing,
worming into (Old English), from the verb*

SMUGAN~*to creep through (Old English)*

All these Old English words derive from the Prehistoric German verb
SMUGAN~*to squeeze through a hole*

Prehistoric German verb Smugan converted to the past tense becomes
SMAUG~*squeezed through a hole*

By converting this verb to its past tense, Tolkien came up with the word Smaug, which he himself termed "a low philological jest."

Despite (or because of) the low jest, Tolkien liked the sound of Smaug. He felt it carried the collective meaning of composite parts in Old English: penetrating, inquiring, burrowing, worming into, and creeping through.

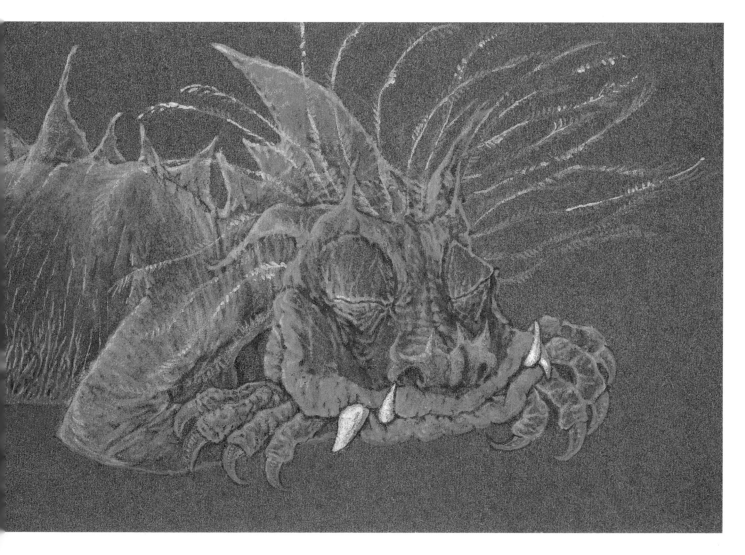

MONSTER → DRAGON + WORM + SNAKE + SE

SERPENT + SNAKE + WORM + DRAGON → MONSTER. SERPENT. MONSTER → DRAGON + WORM + SNAKE +

DRAGON → WORM + SNAKE + SERPENT. MONSTER

ENT. MONSTER → DRAGON + WORM + SNAKE +

SERPENT. MONSTER → DRAGON + WORM + SNAKE + SERPENT.

MONSTER → DRAGON + WORM + SNAKE + S

Furthermore, Smaug was the adjectival form of the Old English verb *smeagan*, which translates as subtle or crafty.

This was exactly what Tolkien wanted to convey in the name of a Dragon: a subtle and sophisticated monster full of crafty twists and turns.

Smeogan ~ *penetrating*
Smeagan ~ *inquire into*
Smaug ~ *subtle, crafty*

Tolkien's solution to the riddle of the Dragon's name: Smaug

Hobbit and Dragon

Armed with the One Ring of invisibility and the sword Sting, Bilbo Baggins had completed the ideal basic training as thief and hobbler by the time he encountered the Dragon. It became increasingly clear that the Hobbit Bilbo Baggins was the perfect choice for burglar-hero to pillage the treasury of the Dragon.

After all, the Hobbit had a great deal in common with the Dragon. Bilbo Baggins was a Hobbit (holbytlan) and smial-dweller, a hole-builder and hole-dweller. Much the same could be said of Smaug, who squeezed through a hole in the mountain to hoard his treasure.

Even more obviously, the Gollum and the Dragon had much in common: Smeagol (worming into, burrowing) and Smaug (a worm squeezed through a hole) are both names constructed from the Old English words smeogan (penetrating) and smeagan (to inquire into).

As Bilbo Baggins had already penetrated the mountain maze of Smeagol Gollum and outwitted that monster in a contest of riddles, he was especially well qualified for his encounter with the Dragon.

Thus it is obvious why a Hobbit was hired to confront the Dragon.

Bilbo Baggins knew how to use the name of the Dragon against the monster and at the same time was wise enough to avoid revealing his own true name to the monster. With his inquiring Hobbitish mind he liked riddles and looking for the roots and beginning of things. Furthermore, it takes a life-long hole-dweller, used to creeping through burrows and worming his way through secret passageways, to penetrate the devious stratagems of the Dragon.

Bilbo Baggins inquired into the meaning of Smaug and found that the monster was indeed subtle and crafty. But he also found that the inquiring mind of Smaug suffered from idle curiosity. Consequently, Bilbo discovered that the Dragon could be distracted with riddles while he spied upon the Dragon and planned his escape.

Bilbo found that Smaug's greatest vice was his vanity. He realized that Smaug was Smug. It was Smaug's arrogance and contempt for his foes that rendered him liable to succumb to the Hobbit's flattery and accidentally reveal his one mortal weakness.

So how does the Hobbit use the answer to the Riddle of the Dragon's Name: "against the penetrating worm?"

How can the penetrating worm be *penetrated* and *slain?*
The answer is in the name:
Smaug *squeezed through a hole.*

Bilbo Baggins learned the secret of Smaug's mortality: a bald patch in the diamond waistcoat covering the Dragon's belly. Soon after, the Hobbit sent word to the hero Bard the Bowman that Smaug the Fire Dragon could only be slain if the hero's arrow could be squeezed through a hole in the jewelled armour covering the Dragon's belly.

When the arrow found its mark, the mighty winged Fire Dragon, Smaug the Golden, was slain and fell from the sky.

XVII. SHIRE SOCIETY

Tolkien's chapter title "A Long Expected Party," which opens The Lord of the Rings, *is a little jest alluding to the first chapter of* The Hobbit, *entitled "An Unexpected Party." However, they are parties (and novels) on an entirely different scale. Bilbo Baggins's little tea party in* The Hobbit *bears little resemblance to his massive Eleventy-First Birthday and Farewell Party that was held some sixty years later.*

At the later Baggins party, we have a portrayal of Hobbit life on an epic scale. With a cast of hundreds of Hobbits we see Shire life painted on a broad canvas in all its comic and vital energy: its traditions, its gaiety, its pettiness, and even what passes for its grandeur. It is a party that climaxes with Bilbo Baggins's vanishing act. However, it is also Frodo Baggins's coming-of-age party, when (as Bilbo's heir) he inherits Bag End, the sword Sting, the One Ring, and the role of adventurer.

Parties are the most revealing time for Hobbits, for although shy of other races, they are intensely gregarious among themselves. Hobbit society largely revolves around excuses for having parties, picnics, celebrations, and festivals that require the consuming of large amounts of food and drink. There is much singing, dancing, gossiping, laughing, joking, giving gifts away, and story-telling at these events.

At Bilbo Baggins's "Long Expected Party," the Hobbits of Hobbiton Hill celebrate with abandon. They hobbyhorsically hobnob with the hobs and the nobs of Hobbit society, from old hobblers to the young hobbledehoys.

Although Bilbo Baggins's party is Tolkien's celebration of the simple joys of Hobbit (and English) country life, there is also a strong, but good-humoured, element of social satire evident throughout the party festivities. Much of it is aimed at puncturing inflated ideas of self-importance in a very petty bourgeois society.

Tolkien spent hundreds of thoughtful hours inventing and "discovering" names and creating complex genealogies of Hobbit families. Much of the complexity and variety of Hobbit society is conveyed through the suggestive aspects of many of their individual names.

Just as the names of Bilbo Baggins, Smeagol Gollum, Smaug the Golden, Gandalf the Wizard, and the Dwarves of Thorin and Company have hidden inner stories to tell, there is no doubt that the multitude who are the party guests all have their own lives and their own tales to tell.

For besides the famous families of Tooks, Brandybucks, Hornblowers, and Bagginses, Tolkien also created a multiplicity of other names, each of which tells its own family saga: Chubbs, Grubbs, Bracegirdles, Goodbodies, Browns, Brockhouses, Bolgers, Proudfoots, Boffins, Burrowses, Ropers, Banks, Butchers, Gamgees, Cottons, Brownlocks, Bunces, Twofoots, Gardners, Goldworthys, Goolds, Greenbands, Overhills, Underhills, Greenhands, Mugworts, Sandymans, Sandheavers, Whitfoots, Noakes, Potts, Sackvilles, Puddifoots, Rumbles, Smallburrows, and Tunnellys.

To these Tolkien added a plethora of individual first names both plain and exotic. Out of these names a whole community and country of Hobbits was born. Tolkien's "discovery" of his Hobbits as individual characters was so vivid that one might imagine the author had actually sent a portrait painter to record the event, and to paint an individual portrait of every single Hobbit at that wonderful gathering!

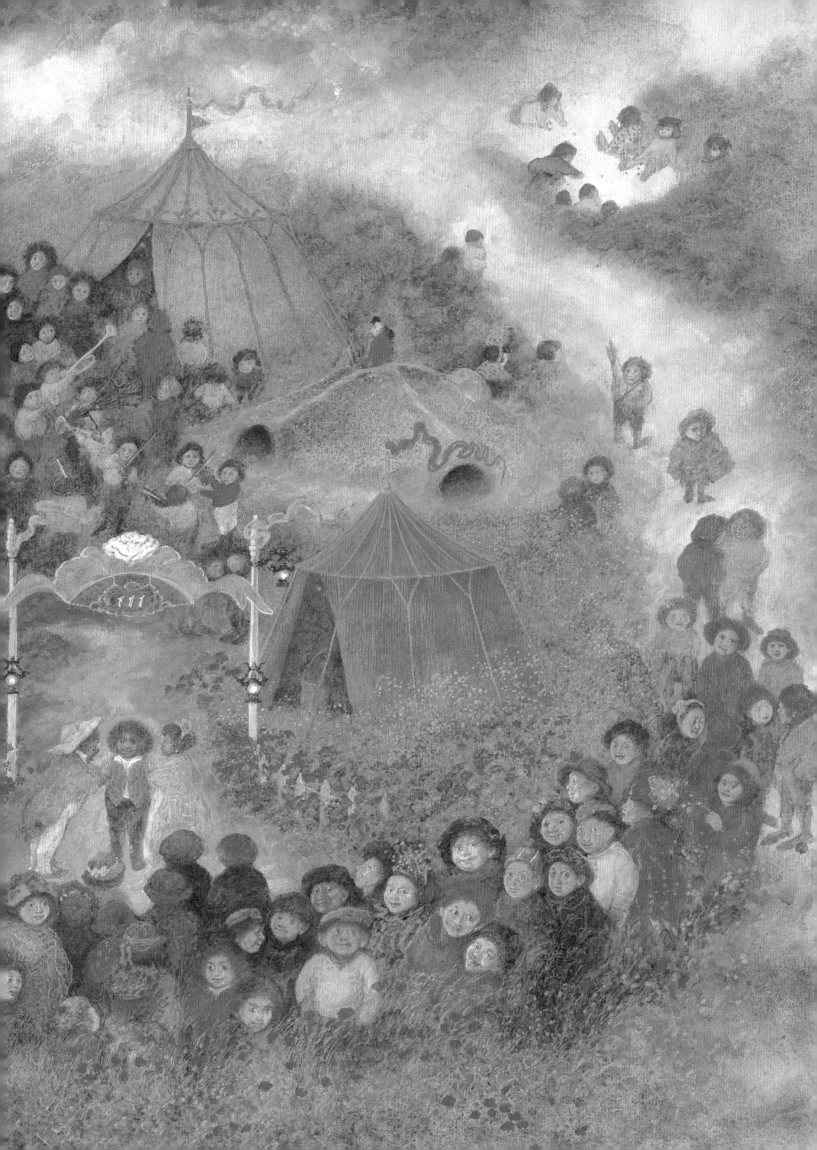

1. Adelard Took

2. Angelica Baggins

3. Asphodel Burrows

4. Berilac Brandybuck

5. Bilbo Baggins

6. Bodo Proudfoot

7. Celandine Brandybuck

8. Daisy Boffin

9. Dinodas Brandybuck

10. Doderick Brandybuck

11. Dora Baggins

12. Dudo Baggins

13. Esmeralda Brandybuck

14. Estella Brandybuck

15. Everard Took

16. Ferdibrand Took

17. Ferdinard Took

18. Ferumbras Took

19. Fillibert Bolger

20. Folco Boffin

21. Fredegar Bolger

22. Gilly Baggins

23. Gorbulas Brandybuck

24. Griffo Boffin

25. Hilda Brandybuck

26. Hugo Bracegirdle

27. Ilberic Brandybuck

28. Lobelia Sackville-Baggins

29. Marmadas Brandybuck

30. Mentha Brandybuck

31. Merimac Brandybuck

32. Merimas Brandybuck

33. Milo Burrows

34. Minto Burrows

35. Mosco Burrows

36. Moto Burrows

37. Myrtle Burrows

38. Odo Proudfoot

39. Odovacar Bolger

40. Olo Proudfoot

41. Otho Sackville-Baggins

42. Pearl Took

43. Peony Burrows

44. Pervinca Took

45. Pimpernel Took

46. Ponto Baggins

47. Poppy Bolger

48. Porto Baggins

49. Posco Baggins

50. Prisca Bolger

51. Reginard Took

52. Rorimac Brandybuck

53. Rosamunda Bolger

54. Ruby Baggins

55. Rufus Burrows

56. Sancho Proudfoot

57. Saradas Brandybuck

58. Saradoc Brandybuck

59. Seredic Brandybuck

60. Willibald Bolger

XVIII. FRODO
the Ringbearer

After Bilbo Baggins of Bag End mysteriously vanished at his famous Eleventy-First Birthday and Farewell Party, Frodo Baggins inherited the family home of Bag End. Orphaned in childhood, Frodo became Bilbo Baggins's heir by virtue of being adopted by his wealthy and eccentric bachelor cousin. However, Bilbo Baggins had left Frodo with more than the family home. He also left the young Hobbit the mysterious Ring of Power that he had acquired from Gollum. It took Gandalf the Wizard another seventeen years to discover the true nature of the One Ring.

With the One Ring, Frodo inherited an adventure even more fantastic than the Quest to Lonely Mountain. Indeed, Dragon-slaying seemed a small matter compared with the challenge that the One Ring was to pose. Sauron, the Lord of the Rings, was the master of all Dragons, Balrogs, Trolls, Wargs, Orcs, and all other evil creatures of the world.

LORD OF THE RINGS: SAURON
~meaning ABOMINABLE *in High Elvish*
~also suggestive of SAUROS, *meaning*
LIZARD *in Greek*

The Ring Lord's name Sauron and the Greek Sauros carry a sense of menace into English because they are suggestive of the prehistoric reptilian age of dinosaurs ("terrible lizards"). Undoubtedly the name must have worked on Tolkien's subconscious, for when Sauron's creatures, the Ringwraiths, trade in their horses for aerial mounts, they climb onto flying monsters that can only be descended from the pterodactyls of the prehistoric Saurian Age.

FRODO THE RINGBEARER
What further baggage was passed on along with the Baggins name to Frodo the Ringbearer? Through our investigation into Bilbo Baggins's heritage we have already sorted out a great deal of the Baggins Baggage, especially those pieces applying to various names of specialized and highly skilled forms of larceny.

However, there is one term that has been much used by the criminal world that seems obviously to be directly connected to the Bag in Baggins. This term is related to, but different from, all the others: Bag Man, Baggage Man, Bag-snatcher, Baggage Smasher, etc.

In the context of the One Ring, there is a startling linkage between the name Baggins and another specialized underworld occupation: the Bagger or Bag Thief.

Bagger, Bag Thief~*a thief who specializes in stealing rings by seizing a victim's hand*

Remarkably, the Bagger or Bag Thief had nothing to do with baggage, but was simply a homonym derived from the French *bague*, meaning "finger ring." It appears to have been in common usage between 1890 and 1940.

BAGGINS → RING THIEF → BAGGER → BAG THIEF → BAGUE THIEF → RING THIEF → BAGGINS

It seems that from the beginning the Baggins name contained the seeds of the plot of both *The Hobbit* and *The Lord of the Rings*. Bilbo and Frodo Baggins were born to be Baggers or Ring Thieves.

What came first, the Baggins or the Baggers?

(Bilbo) BAGGINS → *Bourgeois* → *Burgher*
→ *Burglar* → *Baggage Man*
→ *Bag Man* → *Bag Thief*
→ *Bagger* → *Bague Thief*
→ *Ring Thief* → (Frodo) BAGGINS

Why Frodo?

What's in a name? What were the special qualities that Frodo brought to the Ring Quest?

FRODO (Modern English)
→ *Froda (Original Hobbitish)*
→ *Froda (Old English), meaning Wise*
→ *Frothi (Norse), meaning Wise One*
→ FRODO THE WISE
→ FRODO THE PEACEMAKER

In Old English and Scandinavian mythology, the name Frodo (or Froda, Frothi, Frotha) is most often connected with a peacemaker. In the Old English epic of *Beowulf* there is Froda the powerful King of the Heathobards who attempts to make peace between Danes and Bards. In Norse mythology there is a King Frothi who rules a realm of peace and prosperity. Also, in Icelandic texts we find the expression *Frotha-frith,* meaning "Frothi's Peace" with reference to a legendary "Age of Peace and Wealth."

This is certainly in tune with Frodo Baggins who, by the end of the War of the Ring, becomes a most remarkable peacemaker. Certainly, within the Shire, there was an equivalent Froda-frith or "Frodo's Peace:" the year S.R. 1420, after the Ring War, was known as the "Year of Great Plenty" when the harvest was more bountiful than any in history. This was followed by a golden "Age of Peace and Wealth" for the Shire and its inhabitants. All this was due to the heroic actions of Frodo the Ringbearer.

XIX. *Fellowship of* HOBBITS

SAMWISE GAMGEE. *There is no doubt that Frodo Baggins's friend and servant, Samwise Gamgee, was born to match up to all of our Hocus-Pocus words that apply to the whimsical aspects of the Hobbits: Hoblike as in clownish, Hobnail as in bumpkin, Hobbyhorsical as in comical, Hobbling as in stumbling, Hobble-de-hoyish as in awkward. All of these apply to the rough-cut Samwise Gamgee at the beginning of the Quest of the Ring. And yet he possesses unswerving loyalty to Frodo Baggins and a courageous heart that more than once saves the day.*

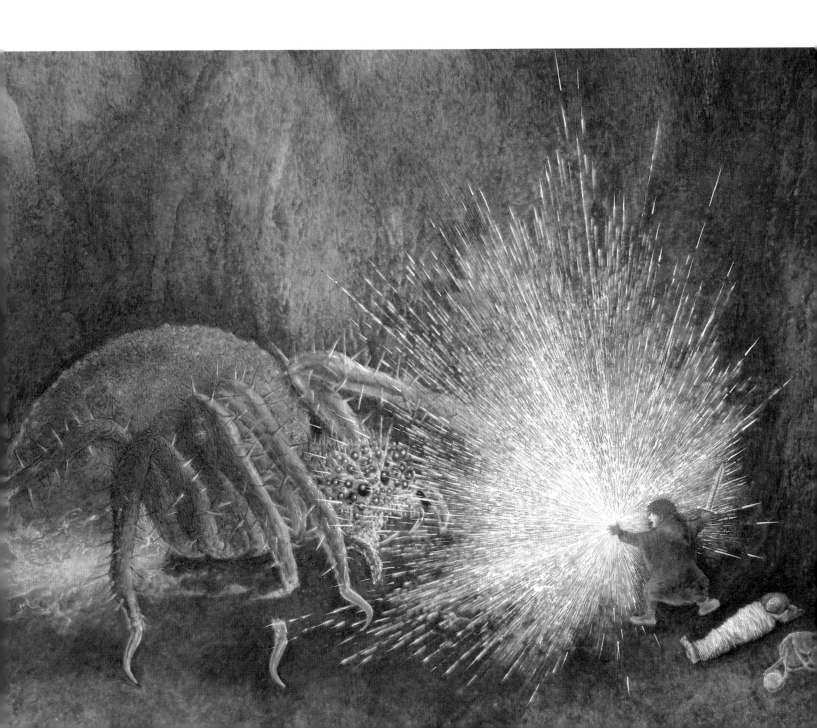

His name is his identity tag: Samwise Gamgee, son of Hamfast Gamgee. His master's name, Frodo, means Wise, so logically enough Samwise's name means Half-wise or Simple. His father's name was equally descriptive: Hamfast, meaning Home-stay or Stay-at-home. These are unambiguous statements about a simple family of garden labourers.

Origin of Samwise:

→ BAN *in original Hobbitish (abbrev.)*
→ BANAZIR *in original Hobbitish,*
meaning Half-wise or Simple
→ SAMWIS *in original Old English*
→ SAMWISE *in transliterated Old English*
→ SAMBA *in Westron*
→ SAM *in Westron (abbrev.)*
→ SAM *in English (abbrev.)*

SAMWISE'S family name GAMGEE was both *descriptive* and *playful.*

Origin of Family Name of Gamgee:

GAMGEE~*Hobbitish translation of*
GALPSI~*abbreviated through usage from*
GALBASI~*meaning from the village of*
GALABAS (GALPSI)
GALABAS, GALAB~*meaning Game, Jest, Joke*
→ BAS~*meaning Wich/Village*
→ GALEBAS
→ GAMWICH~*meaning Game Village*
Therefore, in English translation, the village of
GAMWICH *(pronounced Gammidge)*
changes to GAMMIDGY *and ends up with the name* GAMGEE
GAMGEE → GAME, JEST, JOKE

In the Half-wise Samwise Gamgee we have the perfect foil to his master, the Wise Frodo Baggins. Simple Sam Gamgee is both game for any challenge and, despite terrible hardships, always willing to attempt a jest or joke to keep everyone's spirits up during the Quest of the Ring.

In the end, however, Samwise becomes wise in his humble way, through his great experiences of the wide world and his deep-rooted respect for life. It is not Frodo Baggins, or any of the Baggins clan, who establishes a dynasty of Hobbits, but Samwise

Gamgee and his offspring. It is Samwise Gamgee who inherits Bag End and becomes the respected mayor of the Shire. Samwise Gamgee is a testament to the belief that "the meek shall inherit the earth."

Without Samwise Gamgee's courage and unwavering dedication during those final days, Frodo Baggins could never have reached the Crack of Doom and completed the Quest of the Ring.

Most remarkable of all Samwise's deeds is his courageous fight with Shelob the Great Spider (Shelob being Old English for She-Spider), the unspeakable horror lurking in the pass of Cirith Ungol (Elvish for Spider Pass) in the Mountains of Mordor (Elvish for Black Land). Using the Elf blade Sting and the Phial of Galadriel the Elven Queen, Sam blinded and mortally wounded the monster, then rescued his master.

PEREGRIN TOOK AND MERIADOC BRANDYBUCK

The other two courageous Hobbit heroes of the War of the Ring are Meriadoc (Merry) Brandybuck and Peregrin (Pippin) Took. They were both born to aristocratic Hobbit families: Merry is the heir to the Master of Buckland and Pippin is the heir to the Thain of the Shire. And they both have names suitable for the courageous (if diminutive) knights-errant they are. They are cousins and childhood friends of Frodo Baggins, and through love and loyalty to him become members of the Fellowship of the Ring.

PEREGRIN (Pippin) TOOK
aka Peregrin I, Thirty-Second Thain of the Shire

PEREGRIN → PILGRIM

PEREGRIN *from Latin* PELEGRINUS
~ *foreign, abroad*
→ *Old French* PELEGRIN~*wanderer*
→ *Medieval English* PELEGRIN~*traveller*
→ *Modern English* PILGRIM

Also: PEREGRINE → a small hunting falcon or HOBET

Note on the historic Pippin: Pippin the Short was the King of the Franks and the founder of the Carolingian dynasty. He was also the father of Charlemagne, the Holy Roman Emperor.

MERIADOC (Merry) BRANDYBUCK
aka Meriadoc the Magnificent, Master of Buckland

Meriadoc is a genuine Ancient Celtic name. One Meriadoc is founder of the Celtic kingdom of Brittany and four others were named among the ranks of Celtic knights in the court of King Arthur.

MERIADOC *is a translation from the original Hobbitish* Kalimac.

MERRY *is a translation from the original Hobbitish* Kali, *meaning jolly.*

MERRY~*a variant of Mercy in the 17th century~in Middle English means jolly~while as* Myrige *in Old English means Pleasant. But in Prehistoric German, curiously,* Murgjaz *means short.*

In the Ring Quest, Merry and Pippin provoked the Ents to attack Sauron the evil Wizard of Isengard, and the Hobbits were carried along on the March of the Ents. The largest and strongest race on Middle-earth, the Ents ripped down the walls of Isengard with root-like hands and destroyed the kingdom of the evil Wizard Saruman.*

At the Battle of Pelennor Fields, Merry served as squire to the King of the Riders of the Mark, whose charge broke the siege of Gondor. On that day, Merry became a truly heroic figure when—with the shield-maiden Eowyn—he slew the Ringwraith Witch-king of Morgul.

In the final conflict with the Ring Lord in the Battle of the Black Gate of Mordor, the Hobbit Pippin also won distinction as a warrior. Making a defiant last stand with the army of the Captains of the West against the overwhelming forces of darkness, Pippin slew a huge Troll with his charmed Elven sword before the Black Gate of Mordor.

* During this adventure Merry and Pippin were given Ent-draughts to drink, which stimulated their growth. They grew to measure four feet and six inches, which made them the tallest Hobbits in history!

xx. HOBBITS & RINGS

In The Lord of the Rings, *Gandalf the Wizard tells us that the One Ring had something like a will or a purpose of its own that directed its movement through history. It was apparent to the Wizard that as it slipped from one hand to another—in some mysterious way and for some mysterious purpose—the Ring itself chose each of its masters.*

If one accepts the Wizard's proposition, one is almost compelled to ask a fundamental question:

What is it about HOBBITS *that made them so attractive to the* RING?

The answer is that from the beginning the word Hobbit had a magnetic element in the core of its being that inevitably drew the Ring to it and consequently was responsible for the central plot and climax of *The Lord of the Rings*. That element was the most versatile of Hocus-Pocus words: Hob.

A game of Hob is also called Quoits or Rings. It is played with large flat iron rings (also called quoits) pitched over a pin or peg (called the hob) that is used as a mark on a raised mound or hump (also called the hob). In America the rings have been replaced with horseshoes, but it is essentially the same game.

GAME OF HOB → GAME OF QUOITS → GAME OF RINGS

The Ring Quest is an ancient tale common to cultures all over the world. It is an epic tale of heroic ancestors, but also became a means of conveying the secret rituals of alchemy and metallurgy through the adventures of warriors, smiths, and wizards.

Just as the once bloody sacrificial rites of spring were tamed and ritualized into such harmless pursuits as May Pole dancing and Easter Egg hunting, so the titanic duels fought by Ring Quest heroes have been reduced to a friendly game of Hob played by a pair of hobnobbing villagers. This symbolic re-enactment of the Quest of the Ring was how the game of Hob, Quoits, or Rings came into being.

Few people today are aware of the origin of the game, and consequently give little thought to the ancient contest of the Ring Quest that they unknowingly commemorate (and imitate) as they toss rings or horseshoes at country fairs and fêtes.

Curiously, we also find that the War of the Ring was not decided by the slaying of Dragons, the clash of armies in battle, the siege of cities, or even the collapse of empires. The fate of the world and the climax of the War of the Rings came down to a wrestling match between the Hobbit and Gollum, which was emblematic of the moral dilemma of the Hobgoblin, and the struggle of the Hob and the Goblin.

In the course of *The Lord of the Rings* it was a struggle that literally ranged from the ends of the earth. For Frodo Baggins's Quest began on the Hob of the Hill in Hobbiton in the Shire, and ended on the Hob of Hell on Mount Doom in Mordor.

DOOM → FATE, JUDGEMENT MORDOR → BLACK LAND, DEAD LAND

It was on the edge of the volcanic fissure known as the Crack of Doom that Smeagol Gollum wrestled with Frodo Baggins over the One Ring. It was in these fires that the One Ring was forged, and it was only in these fires that the One Ring could be destroyed.

Ironically, without the evil Gollum, the good Hobbit could not have achieved the destruction of the Ring. The power of the Ring was too great, but at the critical moment Gollum attacked and viciously bit off Frodo's ring finger. Joyfully seizing the Ring, Gollum missed his footing, toppled backward, and literally met his doom as he fell into the fiery abyss.

In this way, the One Ring was destroyed, the War of the Ring was ended, and the Lord of the Rings was vanquished.

Was it really the HOB in HOBBIT that brought RINGS and HOBBITS together?

Did the game of Hob inspire the plot of the epic tale of *The Lord of the Rings*? Or was the whole of the epic tale of *The Lord of the Rings* a story invented to explain the origin of the game of Hob?

It is unlikely that even J. R. R. Tolkien would intentionally have been quite this bizarrely convoluted and elaborately Hobbitish. But one never knows—Tolkien was an unrepentant multi-lingual serial punner. It is conceivable that, in some other dimension, Professor Tolkien may now be sitting back and blowing his smoke rings as he chuckles at the thought of inflicting one more totally obscure philological joke on the unsuspecting and unknowing world.

However, there is perhaps another way of explaining the strange synchronicity of Tolkien's world. Language is a collective creative process that interacts with the creative processes of the individuals who use it. This results in an alchemy that is ultimately far more complex and far more intelligent than any one person. Words have a resonance and meaning that are beyond any single individual's ability to understand fully or predict.

The truth is that words, like magic rings, have something like a will or a purpose of their own that directs their movement through history.

In mysterious ways and for mysterious purposes, words have the power to shape the world, and to transform the lives of those who master them.

Words are older and wiser than any living person. There is no doubt that J. R. R. Tolkien himself would be the first to acknowledge, that from the very beginning, *The Hobbit* had its own agenda.

Bibliography

Allan, Jim. *An Introduction to Elvish*. Hayes, Middlesex: Bran's Head Books, 1978.

Carpenter. Humphrey. *J. R. R. Tolkien: A Biography*. London: HarperCollins, 1977.

Carpenter. Humphrey. *The Letters of J. R. R. Tolkien*. London: HarperCollins, 1981.

Day, David. *Tolkien's Ring*. London: HarperCollins, 1995.

Day, David. *Tolkien: The Illustrated Encyclopedia*. London: Michell Beazley, 1991.

Fonstad, Karen Wynn. *The Atlas of Middle-earth*. New York: Houghton Mifflin, 1981.

Foster, Robert. *The Complete Guide to Middle-earth*. New York: Ballantine, 1971.

Harvey, David. *The Song of Middle-earth*. London: Allen & Unwin, 1985.

Helms, Randel. *Tolkien's World*. London: Thames and Hudson, 1974.

Kocher, Paul H. *Master of Middle-earth*. London: Thames and Hudson, 1977.

Noel, Ruth S. *The Mythology of Middle-earth*. London: Thames and Hudson, 1980.

Shippey, T. A. *The Road to Middle-earth*. London: HarperCollins, 1982.

Tolkien, J. R. R. *The History of Middle-earth: The Return of the Shadow*. London: HarperCollins, 1988.

Tolkien, J. R. R. *The Hobbit*. London: HarperCollins, 1937.

Tolkien, J. R. R. *The Lord of the Rings*. London: HarperCollins, 1954–5.

Tolkien, J. R. R. *The Monster and the Critics and Other Essays*. London: HarperCollins, 1983.

Tolkien, J. R. R. *The Silmarillion*. London: HarperCollins, 1977.

Tolkien, J. R. R. *Tree and Leaf*. London: HarperCollins, 1964.

Diamond of Long Cleeve